THE ART of PLAYFUL LETTERING

DEDICATION

*For the creatives who find charm and beauty
in the imperfections of life and art.*

The Art of Playful Lettering © 2023 by Dawn Nicole Warnaar and
Better Day Books, Inc.

Publisher: Peg Couch
Book Designer: Michael Douglas
Production Designer: Llara Pazdan
Editor: Colleen Dorsey

Library of Congress Control Number: 2023932647

ISBN: 978-0-7643-6713-7
Printed in China
10 9 8 7 6 5 4 3 2 1

Copublished by Better Day Books, Inc., and Schiffer Publishing, Ltd.

Better Day Books
P.O. Box 21462
York, PA 17402
Phone: 717-487-5523
Email: hello@betterdaybooks.com
www.betterdaybooks.com
@better_day_books

Schiffer Publishing
4880 Lower Valley Road
Atglen, PA 19310
Phone: 610-593-1777
Fax: 610-593-2002
Email: info@schifferbooks.com
www.schifferbooks.com

This title is available for promotional or commercial use,
including special editions. Contact info@schifferbooks.com
for more information.

A SUPER-FUN, SUPER-CREATIVE, AND
SUPER-JOYFUL GUIDE TO UPLIFTING WORDS AND PHRASES

• Includes Bonus Drawing Lessons •

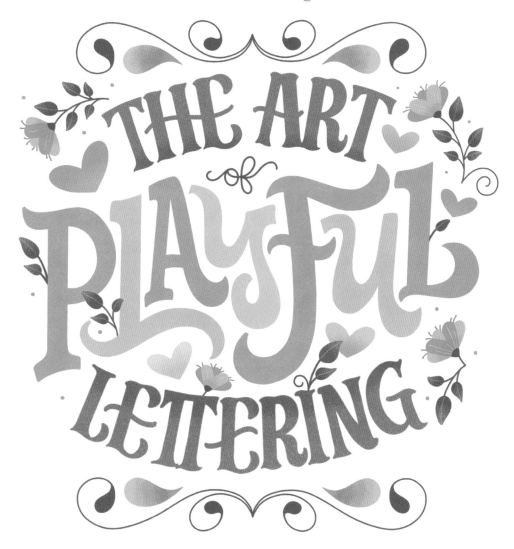

THE ART of PLAYFUL LETTERING

Dawn Nicole Warnaar

BETTER DAY BOOKS®

HAPPY • CREATIVE • CURATED

CONTENTS

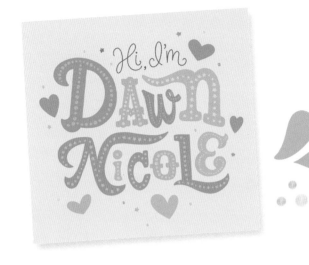

CHAPTER 1:
The Basics of Lettering

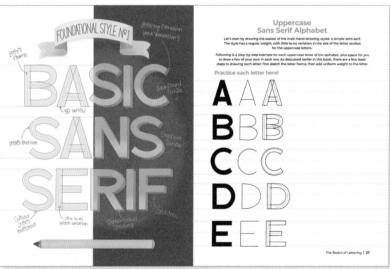

CHAPTER 2:
Cheerful Color

CHAPTER 3:
Whimsical Lettering Styles

Logophile

TALISMAN

Moxie

Esperance

ETHEREAL

HALCYON

Bravado

Kismet

SWITCHEROO

Ameliorate

CHAPTER 3:
Whimsical Lettering Styles *continued*

CHAPTER 4:
Delightfully Easy Illustrations

CHAPTER 5:
Playful Projects

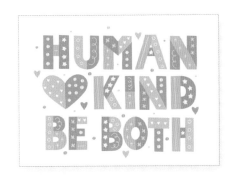
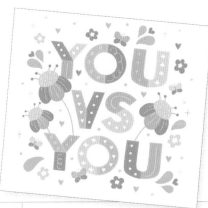
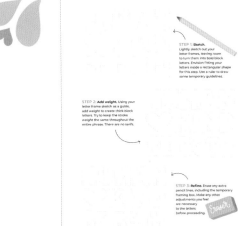
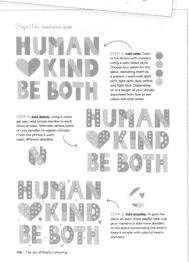

CHAPTER 6:
Extra Goodies

Welcome!

Any day in which I get to spend time creating is a happy day, indeed! Since you're holding this book in your hands, it's probably safe to say that you feel the same.

In many ways, I'm a bit of a perfectionist. (Any fellow Enneagram Ones out there?) Lettering, though, allows me to let go of that need to make things perfect, which can feel extra joyous and free when you're used to coloring inside the lines, so to speak. Hand lettering isn't supposed to be perfect. The imperfections and nuances of drawing letters by hand are part of the charm. If we wanted a design to be perfect, we could simply use a font, and lettering is not a font. I'm sure you're familiar with common fonts like Times New Roman, Arial, and Helvetica, but hand lettering is the art of drawing *custom* letters.

As you start (or continue) your hand-lettering journey with this book, consider these words of encouragement from Jon Acuff: "Be brave enough to be bad at something new." You're not supposed to be amazing at a new thing. It takes practice and work! I'm learning to golf, and I have to remind myself of this quote frequently. Learning a new skill can be frustrating, but it is so rewarding when things begin to click.

And, by the way, you should see my early lettering—"bad" doesn't adequately describe it! But practice makes progress, luckily for both me and you. Yes, we'll learn some lettering rules in this book, but I'm telling you right now that we are also going to break them. As Pablo Picasso said, "Learn the rules like a pro, so you can break them like an artist." If you're a fellow rule-follower type, this may not come easily to you initially, and that's okay. You'll get there, and this book will help you loosen up a bit!

Are you ready to learn the art of playful lettering with me? Let's dive in and have some fun!

Dawn Nicole

Hi, I'm

Dawn Nicole

Meet the Author

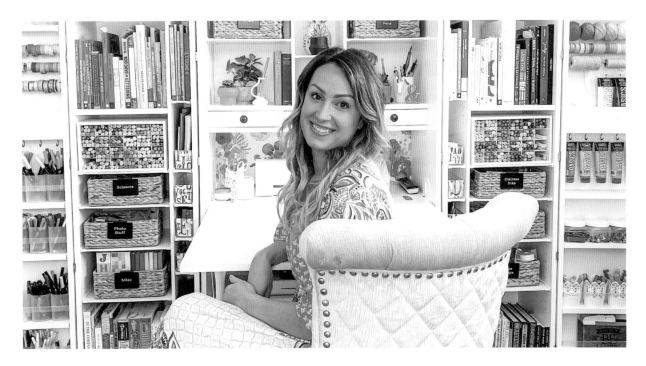

How did you become a hand-lettering artist?

I graduated from college with an English degree and worked in the hospitality field in Charleston, South Carolina. I loved my job and eventually was promoted to HR manager, so I went to graduate school to obtain my MBA in HR management. Not long after, I met a cute Air Force guy outside a bar in downtown Charleston, which changed my life trajectory. His friends had dared him to hit on the next girl to walk by. That girl was me. We got married over a year later and had three babies within four years. In the end, I think he got a lot more than he bargained for!

We move every one to four years, so maintaining a career in HR wasn't feasible. To stay busy, I started craft blogging, which

evolved into what it is today. I'm an accidental "creativepreneur" (creative + entrepreneur). Blogging involves a lot of graphic design work, so I went back to school again for an advanced certificate in graphic design and shifted to doing more design work. That was about 10 years ago!

What inspired you to focus specifically on hand lettering?

During my time in design school, several instructors said I had a knack for mixing typography styles, and that was just the encouragement I needed to fall in love with type. However, after graduating, I discovered that many fonts are pricey to use commercially and that copyright and licensing can be confusing and gray, so I just started making art with my hand lettering.

The more I did it, the better I got (and continue to get) at lettering, and it evolved into a major passion. I love the nuances and organic feeling that doing art by hand creates. The imperfections are part of the charm for me!

What advice do you have for beginners?

Adopt the mantra "Practice makes progress." Commit to practicing often. Be okay with being bad at lettering as a newbie. No one starts out doing fabulous hand lettering or calligraphy. It can be challenging to learn, but it's so much fun! Even after a decade, I get excited to wake up and letter something new.

What do you do when you feel uninspired or unsure of your creative path?

Read and reread *The Crossroads of Should and Must* by Elle Luna. That book made me realize how important it is to follow my passions. While no job is without its downsides, it's a fantastic feeling to love my career so much that, most of the time, work doesn't feel like work! My favorite part is that I can inspire others to be creative daily.

Where can we connect with you?

Visit me at www.bydawnnicole.com and @bydawnnicole on Instagram!

Fun Facts about Me!

I'm friendly, so people are always surprised to find out I'm an introvert and completely content to hang out by myself for days on end.

Places we've been stationed as a military family include Charleston AFB (South Carolina), Altus AFB (Oklahoma), Scott AFB (Illinois), Maxwell AFB (Alabama), Ramstein AB (Germany), and Charleston AFB (again), and, in spring 2022, we moved back to Scott AFB. We'll likely move again in 2025.

Traveling is a powerful source of inspiration for me. So far, we've traveled to Australia, Germany, France, Spain, the Czech Republic, Switzerland, Belgium, Luxembourg, Italy, the Netherlands, and Ireland.

People who meet me in person often comment that at 5'9",
I'm much taller than expected.

I'm known for being easy to work with and always, always, always on time.

Studio Tour

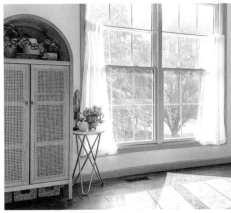

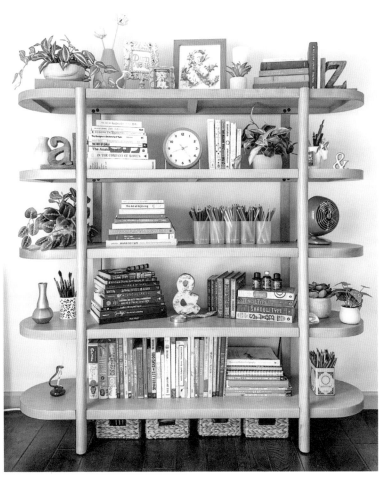

Welcome to my home office!

As a military family, we have moved every one to four years for more than fifteen years. Needless to say, I've had a lot of different home offices of all sizes. We moved into this house just outside St. Louis in March 2022. I especially love how much natural light this room gets in the morning.

After over a decade of working in a creative field full time, I've accumulated more art supplies than I use, especially now that working in the Procreate App on my iPad is my favorite medium. I recently pared down my physical supplies, keeping only my favorites. Lettering and design books take up much of the space on my bookshelves, and I add to my collection frequently. I highly recommend starting your own "Lettering Library" for reference and inspiration.

While I admittedly work from my cozy living-room couch some days, I'm usually in here at my desk. It's positioned in the corner, where I can take in the lovely tree-lined view out my oversized window, benefit from good light for Zoom meetings, and watch TV while I work.

I'll let these photos speak for themselves, but you can visit my website (www.bydawnnicole.com) or my Instagram page (@bydawnnicole) to get more details about my creative space!

How to Use This Book

Put the Lessons into Practice

As you go through the book, you'll notice that there is plenty of room for you to practice right on the pages. You can also use tracing paper if you don't want to write directly on the pages.

That said, you're going to want to practice more than just in the available space. I wanted to fill this book to the brim with educational lettering lessons and inspirational artwork examples, so I tried to balance practice space with these elements. I recommend that you keep a sketch pad handy for your lettering practice and artwork creation.

Above all, don't just read this book and think you'll absorb the info—get that pen and pencil onto the paper!

Don't Forget to Have Fun!

Yes, learning the foundations of the art of lettering is essential, but it is equally important (if not more important) to have fun while you're learning. Consider this your gentle and friendly reminder to be kind to yourself as you learn a new skill. You've got this! If at any point you feel your frustration level rising too high, or you've been trying to create something over and over and keep being disappointed by the results, walk away for a little while. A break will clear your head, give your cramped hand a rest, and remind you that lettering is fun.

Give It as a Fab Gift (Wink, Wink)

Loving this book? Shameless plug alert! You should totally buy another copy and give it to a friend. Add a set of pretty pens or markers to go with it for a simple and thoughtful gift any creative friend will love.

LETTERING

CHAPTER 1:
The Basics of Lettering

Are you ready to dive into some amazing lettering? Take a little time to review the basics in this chapter before you start any of the projects or whimsical lettering styles later in the book. In this chapter, you'll learn essential lettering lingo that will pop up frequently throughout the book, as well as the basic techniques for drawing a letter and for making a lettered composition. Finally, you'll get an opportunity (and plenty of space!) to practice three foundational styles: a sans serif, a serif, and a script.

Lettering
Tools & Materials

One of the best things about the art of lettering is that you don't need fancy tools to create incredible work. As long as you have a pencil and paper, you're ready to do some lettering. Here are the basic supplies I use for nearly every lettering project.

Sketch Pad

You can letter on any paper, of course! But I love a sketch pad with a faint dot grid (such as a Rhodia DotPad); dot grids make it easy to create letters and layouts, even when you don't have a ruler handy.

Straightedge/Ruler

Clear rulers are ideal since you can see through them, which is often handy for your workflow.

Pencils

Any pencil will do; just make sure it's nice and sharp. I'm a big fan of Blackwing pencils.

Erasers

If you're like me, you'll go through the erasers on your pencils quickly, so it's handy to have a more substantial eraser nearby, especially if you're erasing a large area while working on a composition. My favorites are Tombow MONO Black Erasers.

Markers/Colored Pencils

I like to keep an assortment of marker styles on hand—ones with different tip sizes and shapes. I'm partial to Tombow MONO Drawing Pens for outline and detail work. For adding color to my work, I love using alcohol-based markers (such as Tombow or Copic). I generally prefer markers to colored pencils, but, of course, coloring can be done with colored pencils, gel pens, watercolors, and more.

Digital Tool Set

With three electronic elements—a tablet, a wireless stylus pen, and a good design application—you can make digital magic. My personal preferred trio for digital lettering is an Apple Pencil, an iPad, and the Procreate app.

Coffee

This might be optional for you, but it's essential for me!

Lettering Lingo

Did you know that lettering has its own lingo? The diagram below shows some (but not all!) lettering terminology. Search online for "anatomy of typography" to dig into more detail. In addition, I recommend reading the article titled "The A–Z of Typographic Terms" (you can find it here: https://www.monotype.com/resources/z-typographic-terms). It's a stellar resource on this topic!

Most of these terms shown are somewhat self-explanatory, but let's quickly define the handful that you'll see mentioned again and again in this book. The important terms of serif, sans serif, and script are all explained on the facing page.

Monoline

Describes when the weight of a letter (the thickness of the stroke or strokes used to write it) is consistent throughout the letter's shape

Tail/swash

An optional part of a letter that is added or lengthened for decorative purpose

Ligature

A line connecting two different letters so that they become one in a unique way

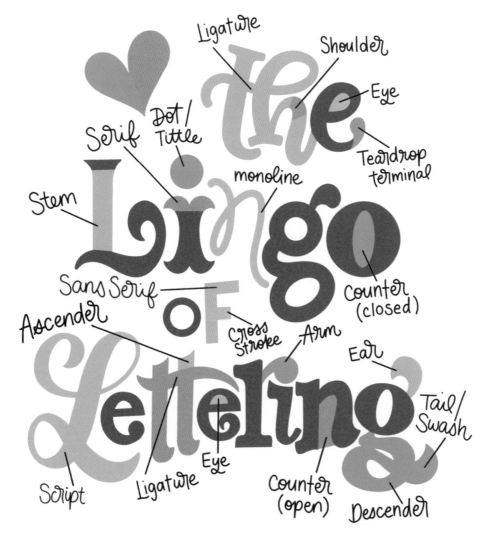

Main Style Types

There are four main style types in lettering. We'll dig into each in detail later in the chapter, but first, here is a comparative overview.

Serif

If you pick up a book in your home and look at the text inside, you'll most likely be reading a serif font. Serif styles have little extra lines or curves at the ends of the letter strokes. These lines are called serifs, or sometimes feet. Substyles of the serif group include slab, old style, neoclassical/Didone, transitional, and glyphic.

Sans Serif

"Sans" means without in French; sans serif fonts are, therefore, without serifs. They are simple and do not have little lines or curves at the ends of the letter strokes. Substyles include square, grotesque, geometric, and humanist.

Script

Script styles emulate handwriting. The letters are often (but not always) connected to each other. Cursive is an example of a script style. Script type can be further classified as casual, formal, calligraphic, or blackletter/Lombardic. Calligraphic styles of hand-drawn script are when you vary the weight of the letter similarly to brush calligraphy (using pressure to control your stroke width).

Decorative

This is the broadest category. I call these the fun types. If a lettering style doesn't fall neatly into the script, serif, or sans serif category, there's a good chance it's a decorative style.

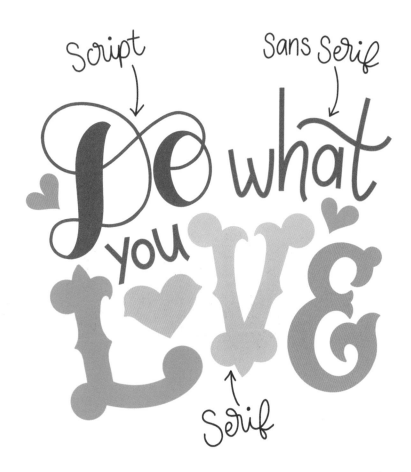

Basic Letter Formation

You will typically write/draw any individual letter following the same set of steps every time.

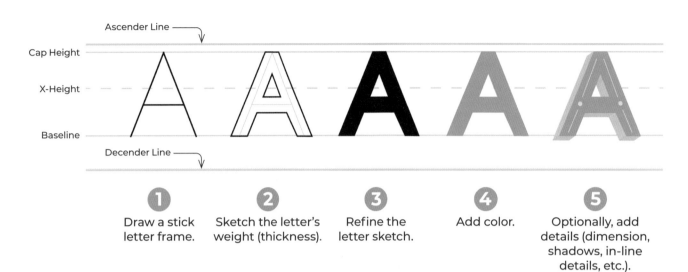

1 Draw a stick letter frame.

2 Sketch the letter's weight (thickness).

3 Refine the letter sketch.

4 Add color.

5 Optionally, add details (dimension, shadows, in-line details, etc.).

When doing hand lettering, you'll use the guidelines above as a basis and take creative liberties to make your lettering more dynamic. Below, I've shown how you might do this with the word "lettering." I've used only the main guidelines (baseline, x-height, and cap height) to simplify. I find it's less creatively restricting to just imagine the ascender and descender lines. (By the way, x-height means the height of the lowercase "x" in that particular lettering style!)

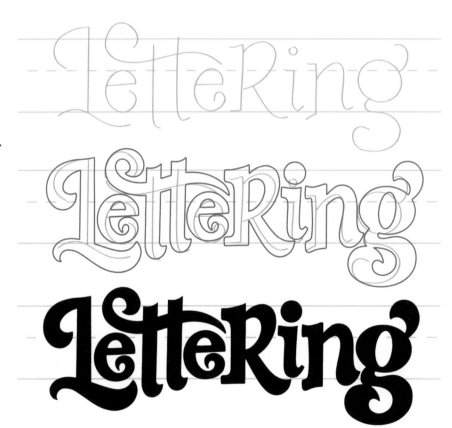

Basic Lettering Composition

Here are the basic steps to making any lettering composition.
If you stick to these every time, you're more likely to create something you like
and not have to spend as much time erasing and reworking.

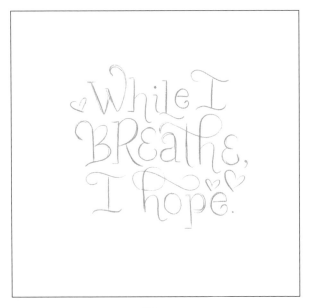

Sketch and then frame. Fill a full page with 5–10 sketches for every project. One or two will be worth refining into a finished piece. Draw the letter frames for your chosen sketch.

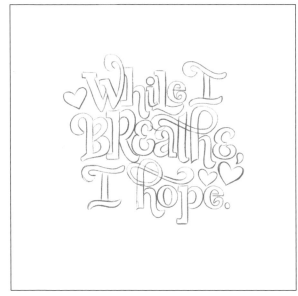

Refine the lettering. Sketch the lettering weight and simple details.

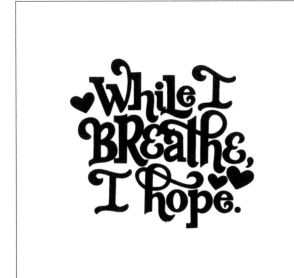

Finalize the lettering. Carefully draw all your letters in a final, polished form. I filled mine with black as I finished them.

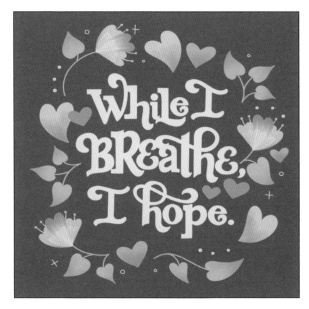

Make it pretty! Now you can finally add the fun parts: color, dimension, shadows, illustrations, doodles, etc.

Let's Draw Some Letters!

Now that we've learned the basics of hand lettering, we'll spend the following 24 pages putting it into practice through three foundational styles. You'll learn a sans serif alphabet, a serif alphabet, and a script alphabet. We'll focus on the uppercase letters for each style, but I've also included a lowercase letter set you can use for reference or tracing. I'll also share handy tips to level up your lettering, along with artwork that shows you how to make the style more playful in a finished piece. Later, in chapter 3, you'll learn 10 playful lettering styles that build further on these fundamental styles. Before we continue, here are some tips.

Using the Worksheets

While you're welcome to practice right on the pages of this book, you can also make copies of the worksheet pages or use tracing paper if you want to be able to practice more than once.

Creating a Relaxing Environment

I like to create a calming space while practicing and encourage you to do the same. This usually means lighting a candle in my favorite scent, turning on some great music, and enjoying a mug of coffee or tea. Making your practice time a vibe is a great way to take the pressure off and unwind!

Practice Makes Progress

Commit to practicing often. I like to tell my lettering students to shoot for completing one worksheet per day. You don't have to spend hours drawing (although you can if you have the time). Short, frequent, high-quality practice sessions are a very effective way to grow your skills!

It's Not a Font!

Lettering artists can get a bit persnickety about this distinction. In simple terms, hand lettering is the art of drawing letters. You're typically creating one-of-a-kind designs each time you draw a piece of hand-lettered art. When typing on your computer, however, you are using a font, such as Arial or Times New Roman. That's why you won't see me use the term "font" much in this book.

BASIC SANS SERIF

Lettering Extrusion
(a.k.a. "dimension")

Letter frame

Background Texture

No serifs!

Letter outline

Gradient Texture

Curved Letter overshoot

Little to no width variation

Dimensional Shading

Shadow

Uppercase
Sans Serif Alphabet

Let's start by drawing the easiest of the main hand-lettering styles: a simple sans serif. The style has a regular weight, with little to no variation in the size of the letter strokes for the uppercase letters.

Following is a step-by-step example for each uppercase letter of the alphabet, plus space for you to draw a few of your own in each row. As discussed earlier in this book, there are a few basic steps to drawing each letter: first sketch the letter frame, then add uniform weight to the letter.

Practice each letter here!

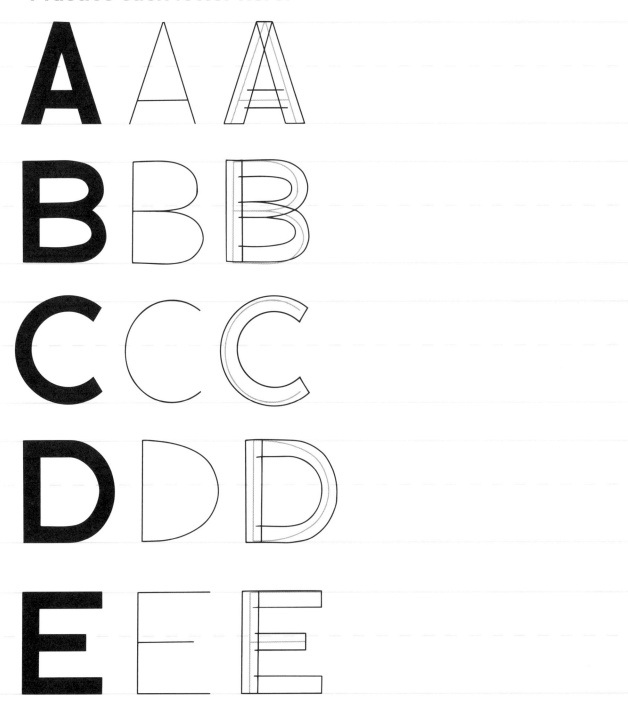

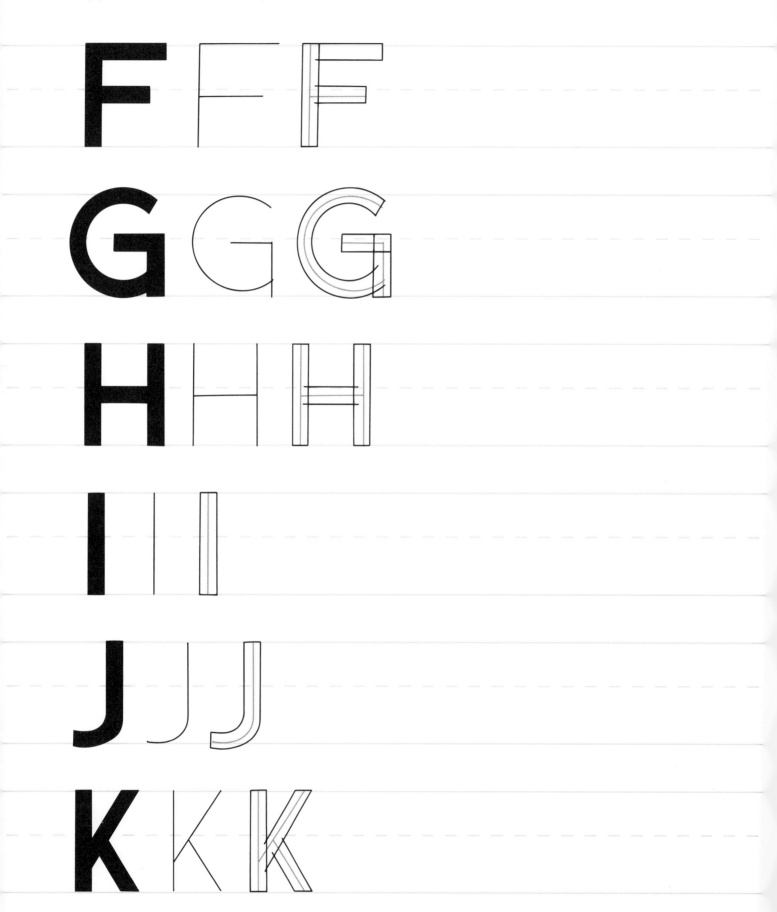

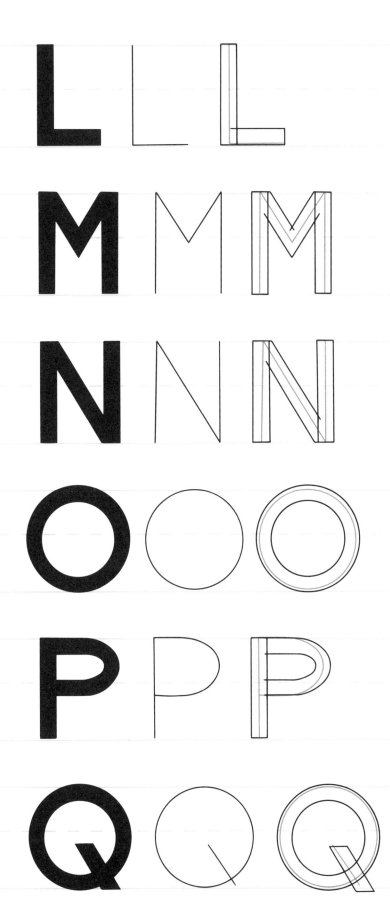

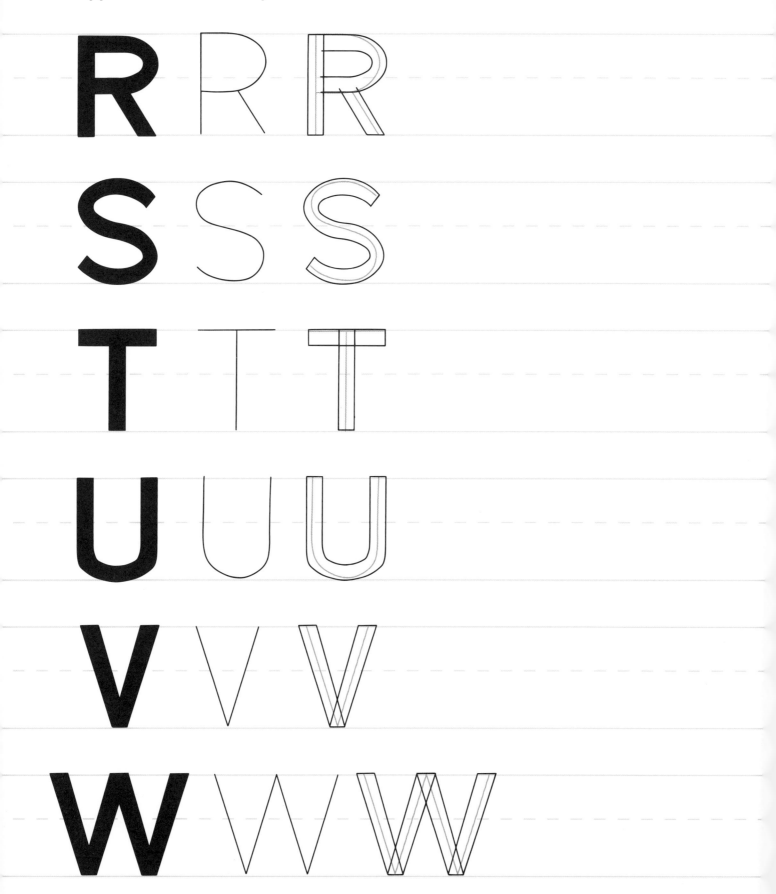

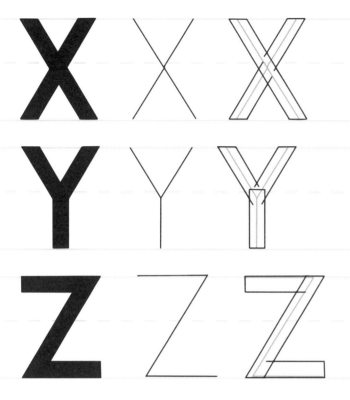

Level Up Your Lettering

Use the base forms of the sans serif letters you just learned and make simple changes to add your own style. I've drawn a few examples here to get you started. Try creating a few of your own!

KKK QQQRRR

Lowercase
Sans Serif Alphabet

There are many ways to draw simple lowercase sans serif letters. Here's one example for you to use for inspiration. Notice that some of these lowercase letters have slight width variations, like the "a" and the "u."

abcdefghi
jklmnopqr
stuvwxyz

abcdefghi
jklmnopqr
stuvwxyz

Make It Playful!

I altered the basic uppercase sans serif letters (as described in the labels below) to add my own style to this artwork. You can take any composition from simple to stylin' by finding fun ways to edit your letters to make them more exciting and playful.

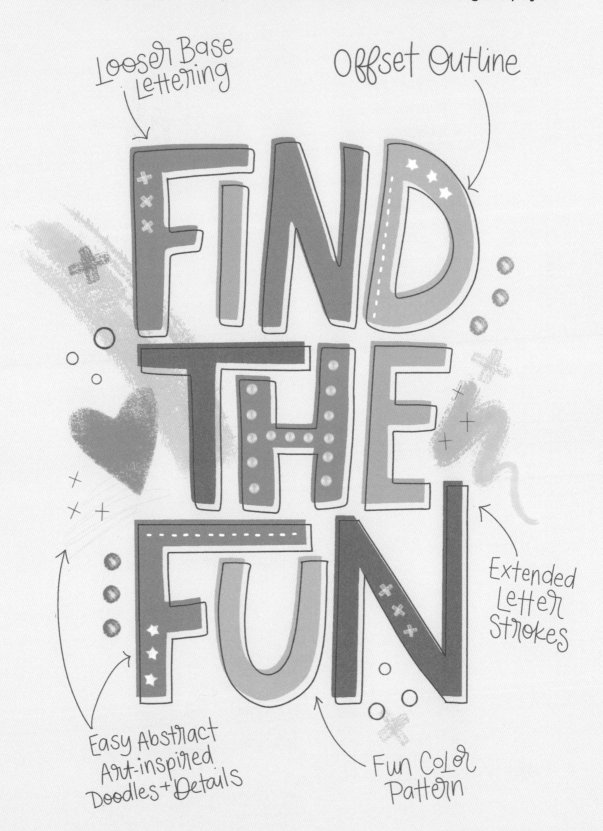

Looser Base Lettering

Offset Outline

Extended Letter Strokes

Easy Abstract Art-inspired Doodles + Details

Fun Color Pattern

BASIC SERIF

Letter frame

Letter outline

Background Texture

Drop Shadow

serifs!

Curved Letter overshoot

moderate width variation

Inline Lettering Detail

Uppercase
Serif Alphabet

We will build upon what we learned with the sans serif letters to create the serif letters. This style also has a regular width, but this time we will have some weight variation in the widths of the letter strokes. Upward strokes are thinner than downward strokes.

Following is a step-by-step example for each uppercase letter of the alphabet, plus space for you to draw your own in each row. As discussed earlier in this book, there are a few basic steps to drawing each letter: first sketch the letter frame, then add weight to the letter, then add the serifs.

Practice each letter here!

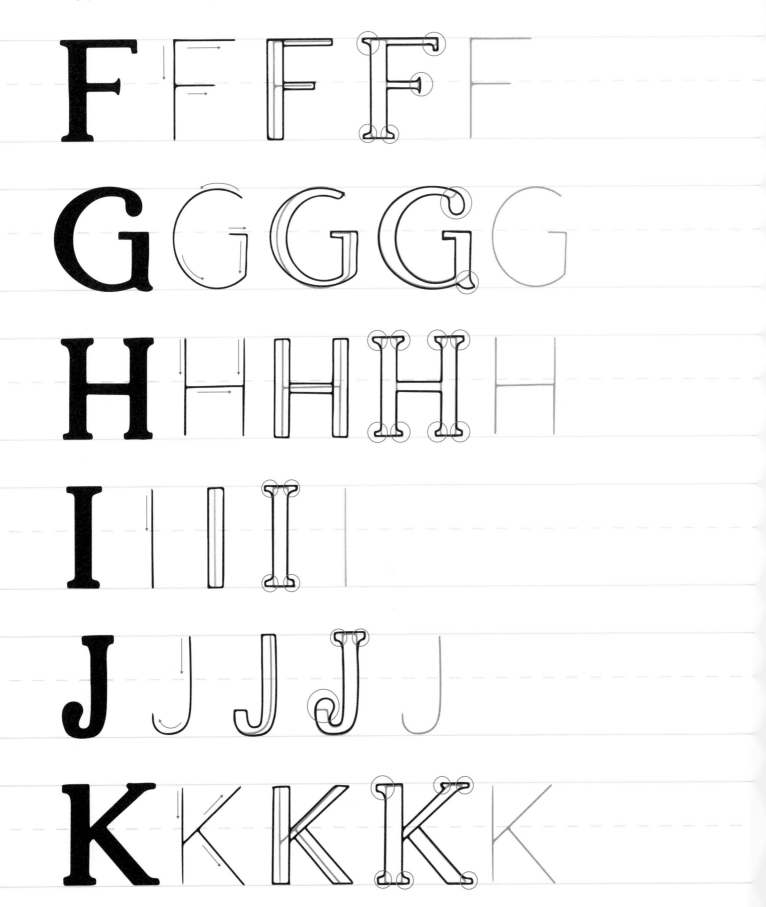

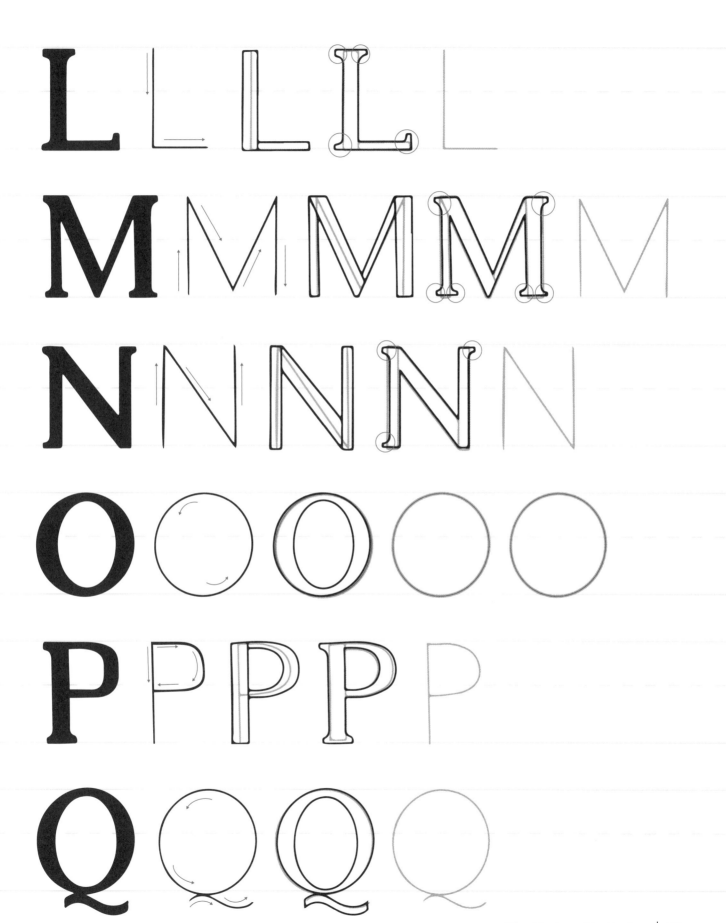

R R R R R

S S S S S

T T T T T

U U U U U

V V V V V

W W W W W

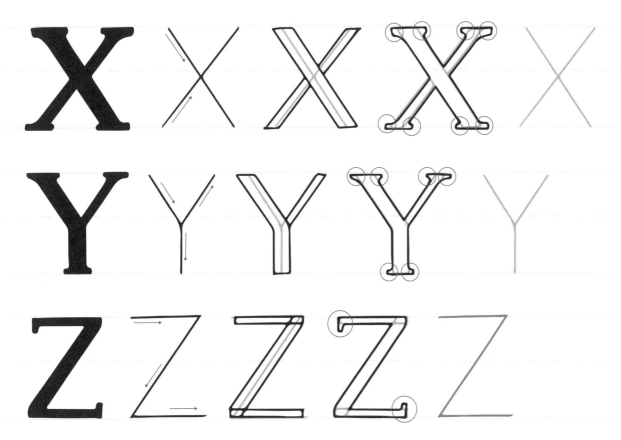

Level Up
Your Lettering

The serifs of certain letters are often drawn incorrectly. The most common culprits are the letters "C," "N," "S," and "W." Study classic serif fonts and pay special attention to how the serifs are placed on each letter stroke.

For an alphabet with variable weight in the letters like this one, pay special attention to the upstrokes and downstrokes. They dictate where the thick and thin weights go. Letters such as "M," "N," and "W" are often drawn incorrectly by beginners.

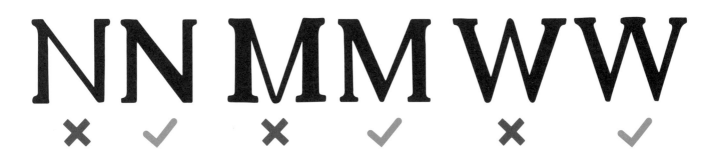

Lowercase
Serif Alphabet

Again, there is more than one way to draw simple lowercase serif letters. I've drawn you a full lowercase set here, including two different versions for the letters "a" and "g"— these extras are typewriter styles known as "double-story a" and "double-story g."

aabcdefggh
ijklmnopqr
stuvwxyz

aabcdefggh
ijklmnopqr
stuvwxyz

Make It Playful!

Modifying the letters themselves isn't the only way to jazz up your lettering.
I made simple serif lettering more playful here through other artistic choices. Things like
the phrase choice, color use, and the addition of florals collectively make this piece more fun.
Try taking a common phrase or aphorism and changing it to make it more personal.
For example, instead of "born to be wild," I opted for "born to be mild."

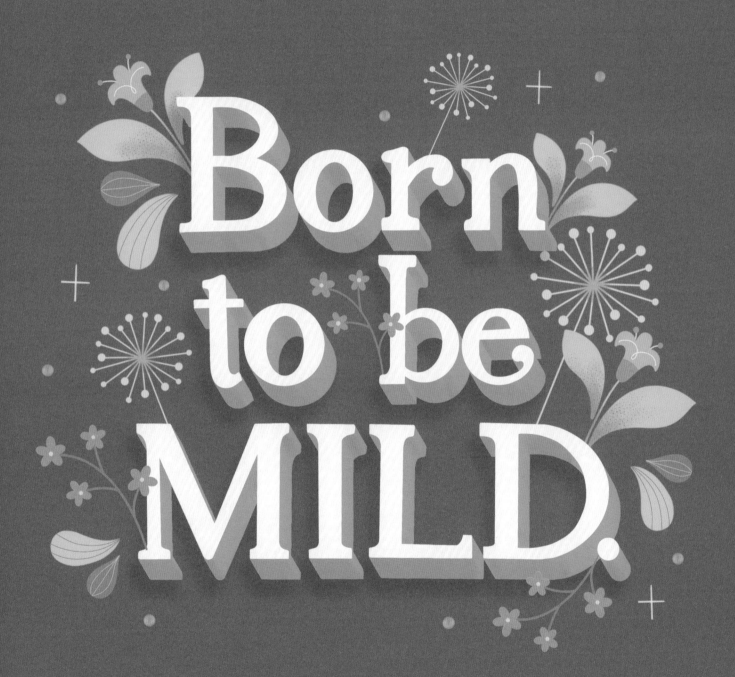

FOUNDATIONAL STYLE №3

Letter frame

Flourish

Background Texture

Highlights

Stacked Color Drop Shadow

Script

Letter outline

thin upstroke + thick downstroke (width variation)

Shadow

gradient ombré color fill

Uppercase
Script Alphabet

It's time for our third and final foundational lettering style: script. The weight of this particular script lettering is calligraphic style. This means it mimics the thin upstrokes and thick downstrokes created by traditional calligraphy. With calligraphy, you use either a dip pen or brush pen and vary your pressure to control the width of the stroke. We'll apply that principle to how we add weight to our script letters. The arrow diagram below is a visual representation of stroke weight for upstrokes and downstrokes.

Since this is an art form, sometimes breaking the rules is okay! You'll notice that I prefer the weight of the leg of my letter "K" to be thin, even though it's technically a downstroke. Visually, I find it looks more aesthetically pleasing when thin most of the time.

Swashes and flourishes can be weighted or not. I use a mix of both depending on the lettering piece I'm working on.

Thin Stroke (Upstrokes)

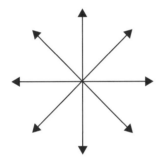

Thick Stroke (Downstrokes)

Practice each letter here!

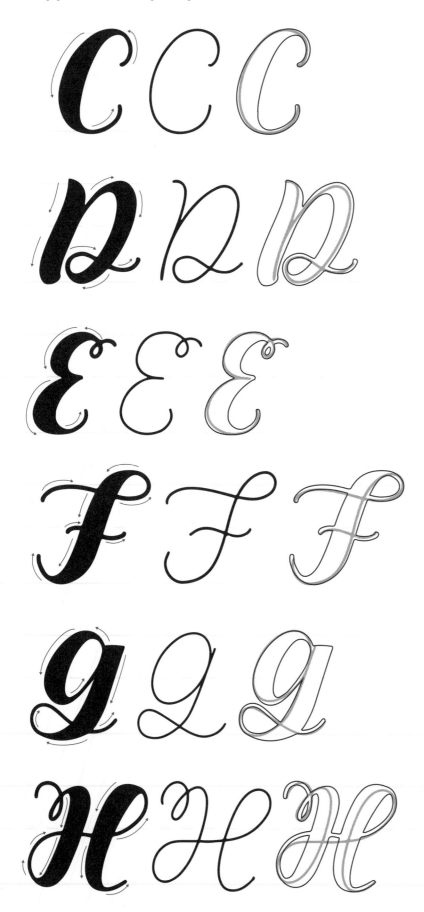

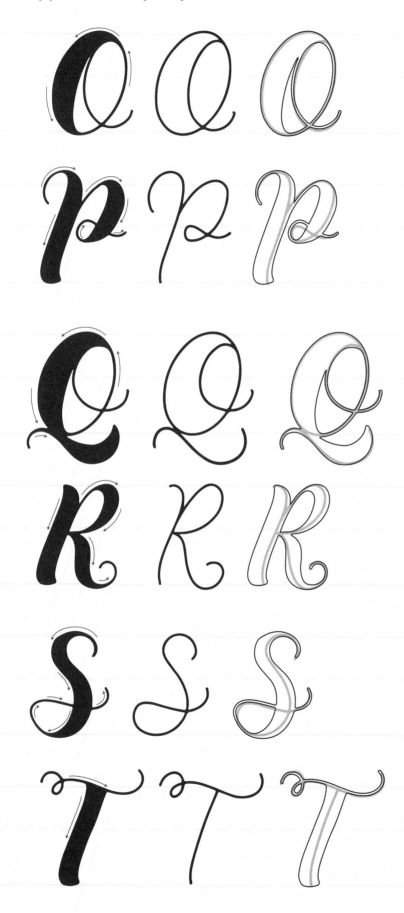

U U U

V V V

W W W

X X X

Y Y Y

3 3 3

Lowercase Script Alphabet

Here's a lowercase alphabet example for script lettering you can use to practice. As with the uppercase alphabet, there is a strong emphasis on the contrast between thick and thin strokes.

abcdefghij
klmnopqr
stuvwxyz

abcdefghij
klmnopqr
stuvwxyz

Make It Playful!

In this piece, I've done simple things to create a more exciting piece of artwork.
I altered the slant of the baseline for each word and added flourishing and a bunch of hearts.
I'm an unapologetic overuser of hearts in my work!

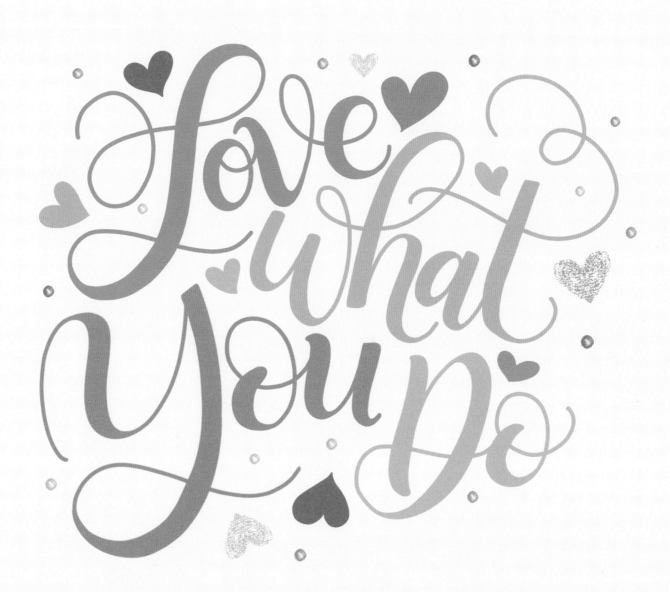

EVERY Letter TELLS A Story

Combining
Lettering Styles

As we wrap up this chapter, I want to cover one last topic before we move on. Combining lettering styles can be tricky, but it's a great way to tell a visual story with your artwork. In design school, I learned that combining only two to three font styles is best. As a general rule, I carry that over to combining lettering styles. Unless you're creating an intentionally doodle-y, eclectic style (which we'll cover later in this book), stick to combining two or three styles max within the same piece of artwork. I've drawn some pairs of styles that work well together below to get you started!

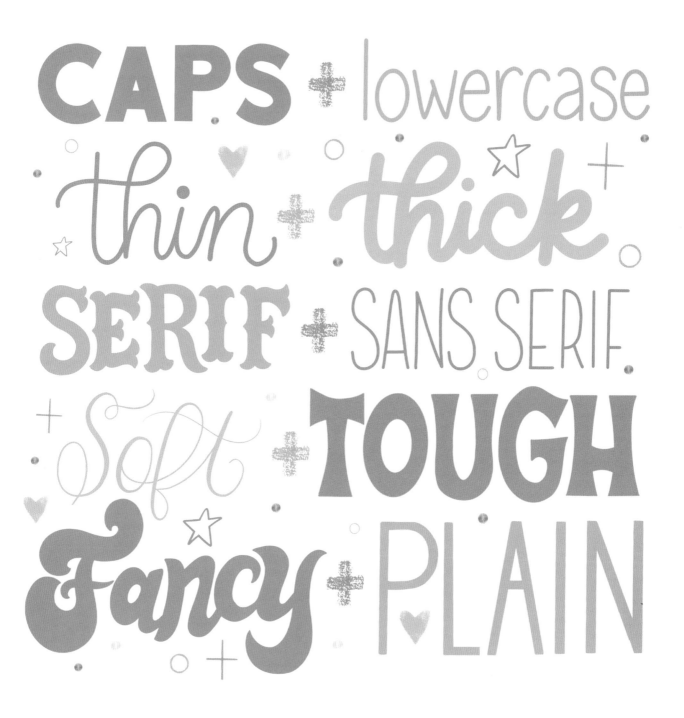

CAPS + lowercase

thin + thick

SERIF + SANS SERIF

Soft + TOUGH

Fancy + PLAIN

COLOR

CHAPTER 2:
Cheerful Color

What is playful lettering without color? Not so playful!
Now, I'm not against black-and-white work, but my
personal style, and the aesthetic I teach throughout
this book, definitely places importance on color within
your compositions. In this chapter, you'll find guidance
for choosing colors as well as five spectacular
ready-to-use palettes for physical and digital work.
I hope to inspire you to experiment with and
think about color as you make your art!

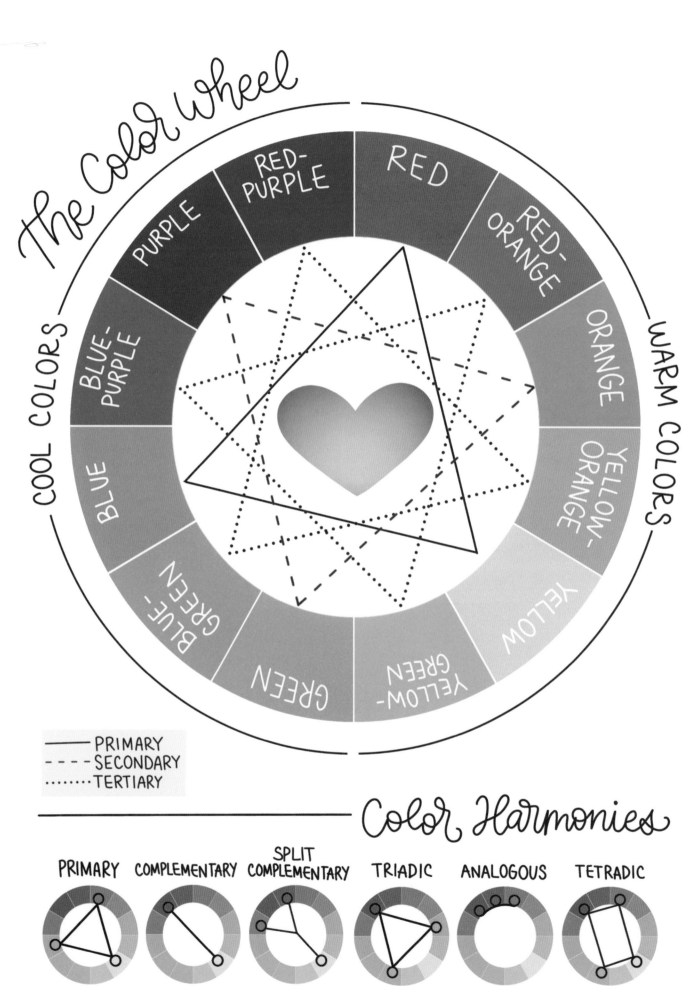

The Color Wheel

RED-PURPLE

PURPLE

RED

RED-ORANGE

BLUE-PURPLE

ORANGE

COOL COLORS

WARM COLORS

BLUE

YELLOW-ORANGE

BLUE-GREEN

YELLOW

GREEN

YELLOW-GREEN

—— PRIMARY
- - - SECONDARY
······· TERTIARY

Color Harmonies

PRIMARY COMPLEMENTARY SPLIT COMPLEMENTARY TRIADIC ANALOGOUS TETRADIC

Color Theory

In design school, I took an entire class devoted to color theory, so I feel it's an important topic to cover in this chapter. Many creatives have an eye for what colors go well together, but there is a science behind it. The color wheel is something I remember learning in grade school, but the terminology didn't stick with me over the years, and I'm betting the same is true for you. So, let's cover some noteworthy color terminology.

The **primary colors** are red, blue, and yellow. You cannot mix other colors to create these colors; all other colors come from these three colors.

The **secondary colors** are orange, green, and purple. These colors are created when you mix two primary colors in equal amounts.

Tertiary colors are created by mixing a primary color and one of its adjacent secondary colors. For example, if you mix the primary color blue with its adjacent secondary color purple, you get the tertiary color blue-purple.

Hue is another word for color. When we add black to a color, it is called a **shade**. Adding white to a color creates a **tint**. And adding gray to a color creates a **tone**.

Color harmonies are colors of a specific relation to each other on the color wheel that go well together. You can pick any fixed set of colors on the basis of this "geometric" arrangement and have a great palette to work with. Here are some examples, which are shown visually on the facing page:

- **Complementary:** Two colors that are directly opposite each other on the color wheel

- **Split complementary:** Any base color and the two colors directly adjacent to its complement

- **Analogous:** Any three colors that are found side by side on the color wheel

- **Triadic:** Three colors evenly spaced around the color wheel

- **Tetradic:** Four colors evenly spaced apart in a rectangular shape

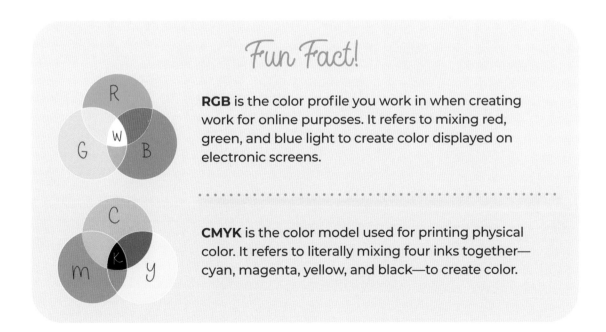

Fun Fact!

RGB is the color profile you work in when creating work for online purposes. It refers to mixing red, green, and blue light to create color displayed on electronic screens.

CMYK is the color model used for printing physical color. It refers to literally mixing four inks together—cyan, magenta, yellow, and black—to create color.

The Psychology of Color

You're likely aware that colors can make you feel a certain way. Think about how you feel as you watch a beautiful sunset over a turquoise ocean, walk through the greenery of an abundant garden, or step into a pastel-hued baby nursery. The emotions associated with each color can vary from source to source, but here's a general list to get you started. Consider these emotional associations when you are choosing colors for a work that has a particular goal. Are you creating a party invitation? Fun and energetic colors might be best. Are you drawing a sign? Attention-grabbing or urgent colors could be a good way to go. Are you designing a business card? Maybe muted and calm colors will work. Always keep the goal in mind, but don't be afraid to buck expectations, either!

Pink: sweet, romantic, compassionate, sensitive

Red: energetic, bold, exciting, love, urgent, danger

Orange: friendly, cheerful, confident, brave

Yellow: happy, warm, creative, optimistic, caution

Green: nature, peace, growth, healing, fresh, quality, health

Blue: trust, loyalty, strength, peace, stability, dependable

Purple: royalty, luxury, imagination, wise, ambitious, magical

Black: formal, dramatic, sophisticated, death, evil

White: simple, clean, innocent, honest, hope, light, goodness

Gray: neutral, stable, balanced, mature, calm

How to Use the Color Palettes

Let's move on to some playful color palette ideas you can use in your lettering work! In the five palettes on the following pages, you'll see a fully developed piece of art next to the six-color palette used to create it. For each palette, I provide both the basic color names for the colors as well as the hex color codes for the exact digital hues.

The hex color codes will serve you well if you are **working digitally** instead of physically and want to replicate the exact colors. The format for hex codes is a hashtag followed by six letters and/or numbers (i.e., #000000). Design programs such as Procreate, Photoshop, and Illustrator will allow you to input the hex code to select the correct color.

If you're working with **physical media**, such as markers, colored pencils, watercolors, etc., simply do your best to match the color shown, but don't be frustrated if you have trouble replicating it exactly. Sometimes beautiful results come from so-called errors! You can also, of course, make conscious choices to swap out or simply remove a color from a palette to change the effect or adapt it to your needs.

Want more color inspiration? You can find more palettes on my blog, on Instagram, on Pinterest, and, of course, through a web search. I also send out fresh color palettes in my monthly newsletter, *The Creative Catchup*.

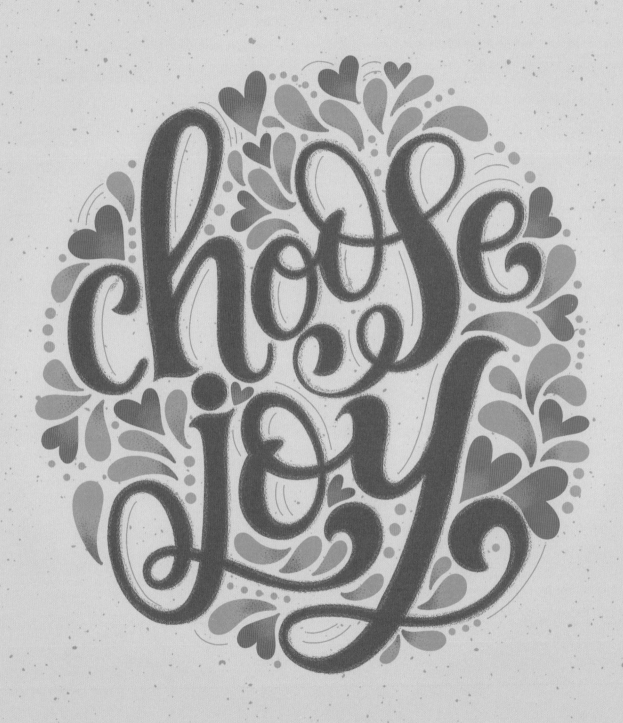

PLAYFUL PALETTE

NO. 1: CARIBBEAN JOY

RED
#e16460

PINK
#d26e9e

YELLOW-ORANGE
#e2b755

GRAYISH BLUE-GREEN
#c2ded2

CYAN
#45b1ae

DARK CYAN
#1c708f

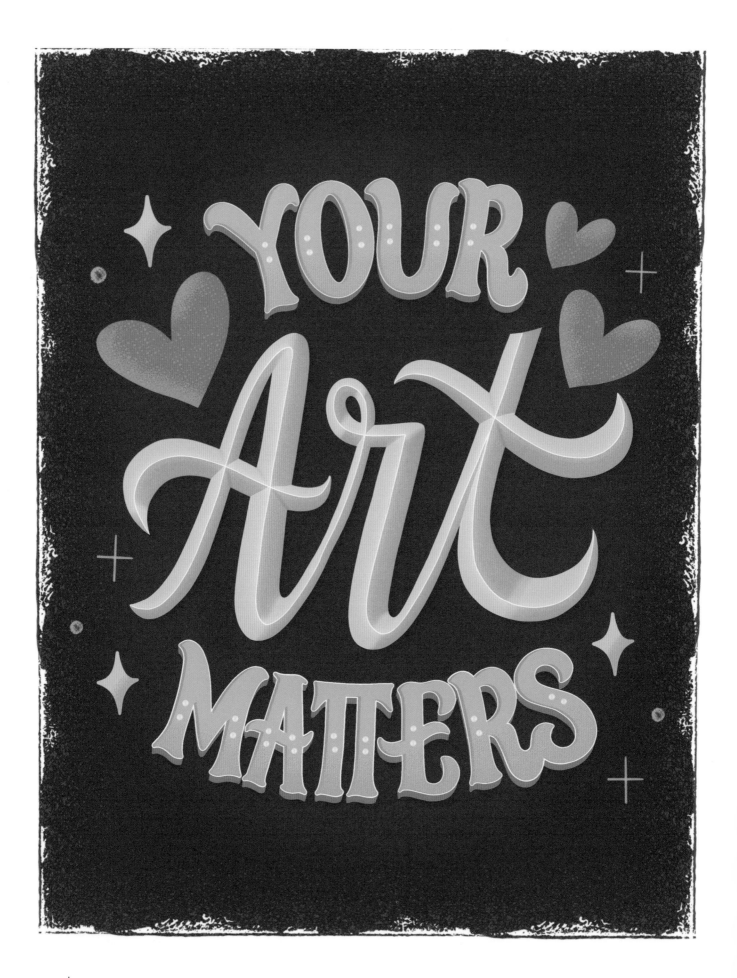

PLAYFUL PALETTE

NO. 2:
AUTUMN BAKERY

DARK RED-ORANGE
#e6775d

LIGHT RED-ORANGE
#ecb2a1

YELLOW-ORANGE
#e8d7a3

ORANGE
#f2b345

CYAN
#92cbc0

DARK MAGENTA
#4b1d4e

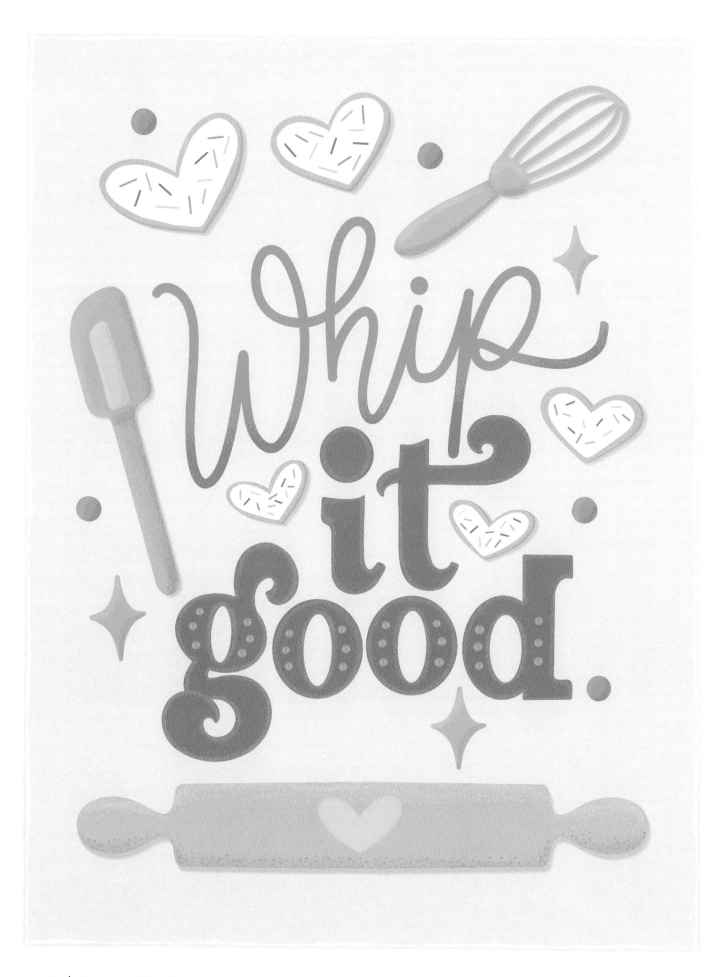

PLAYFUL PALETTE

NO. 3:
WHIPPED PASTELS

BEIGE-ORANGE
#f4d8c2

LIGHT ORANGE
#f0c5a1

LIGHT PINK
#ecb3c5

PINK
#e78fab

LIGHT MINT
#c2e2d9

DARK MINT
#9fd2cd

PLAYFUL PALETTE

NO. 4:
PUNCHY BRIGHTS

CORAL
#e4a39c

REDDISH PINK
#e47a94

HOT PINK
#d8548d

YELLOW-ORANGE
#f3c255

BLUE
#315091

DARK BLUE
#273671

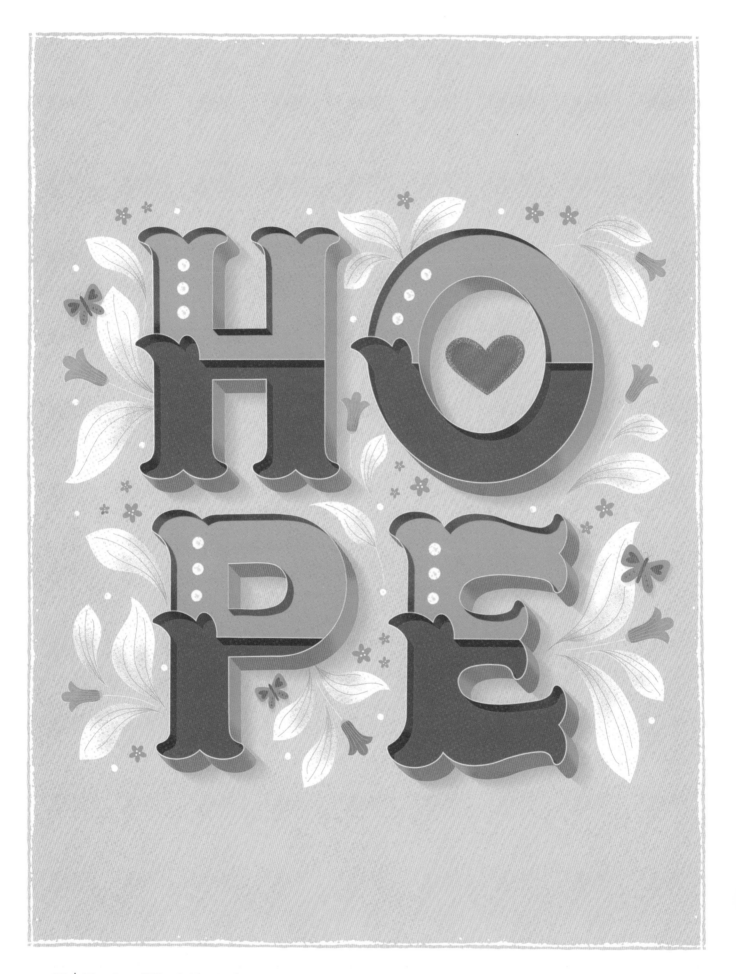

NO. 5:
HOPEFUL BLUSH

LIGHT CORAL
#f7dbd7

PINK
#ea9bb1

PINK-RED
#e57890

DARK PINK-RED
#e05d79

CYAN
#3ab7c9

DARK CYAN
#006c89

CHAPTER 3:
Whimsical Lettering Styles

This is what you came for! In this chapter, you'll learn and practice 10 diverse lettering styles that you can apply in so many ways. From serif and sans serif styles to wacky styles and pretty scripts, there's something fun on every page. Each style comes complete with a full alphabet (or two), tips, space to practice, and sample art pieces that you can re-create or simply be inspired by. Feel free to jump around from style to style—choose the ones that speak to you to work on first, but don't hesitate to tackle a style that seems odd or more difficult to you, because you might just find that you love it!

Overview of 10 Lettering Styles

Here's a look at all the lettering styles you'll learn to draw in this chapter.
At the end of the chapter, I'll share tips for making these styles your own! I created
many of these styles on the fly for various lettering work, but I hadn't taken
the time to design a complete alphabet for each until writing this book.

STYLE 1: A typewriter-inspired slab serif with low-contrast weight variation (page 72).

Logophile

STYLE 2: A fairytale-inspired style that mixes elements of slab serifs and swashy scripts (page 80).

Esperance

STYLE 3: A monoweight script that's modern and clean, yet still playful and fun (page 88)!

Bravado

STYLE 4: An all-caps decorative serif inspired by Gothic wrought-iron work (page 96).

TALISMAN

STYLE 5: A high-contrast style that's part serif, part script, and uses caps unconventionally (page 104).

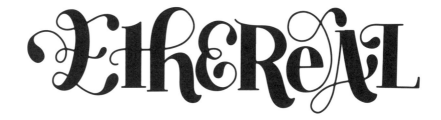

STYLE 6: A high-contrast, romantic style that's a playful blend of classic and modern (page 112).

STYLE 7: A monoweight sans serif ideal for adding lettering to illustration-heavy artwork (page 120).

STYLE 8: A mix of low-contrast and no-contrast letters with Tuscan Gothic serifs and swashes (page 128).

STYLE 9: An all-caps style featuring curvy serifs, fun crossbars, and Gothic-inspired details (page 136).

STYLE 10: A mixed-up decorative style that playfully breaks the rules (page 144)!

LETTERING STYLE № 1

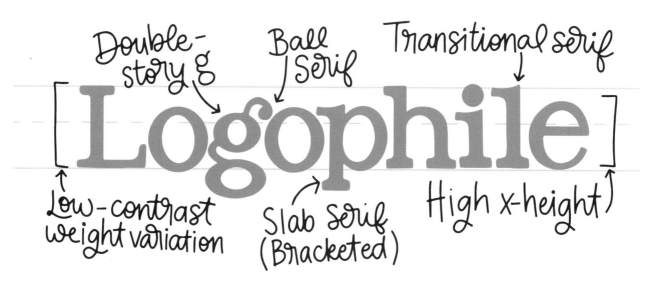

Double-story g

Ball Serif

Transitional serif

Logophile

Low-contrast weight variation

Slab Serif (Bracketed)

High x-height

This lettering style is a typewriter-inspired slab serif with low-contrast weight variation. Because of its vintage vibe, it is very forgiving of little mistakes—anything that doesn't turn out exactly as intended will simply look like a purposeful part of the aesthetic! This is a great choice for people who like structure (but aren't too rigid), and it can be easily injected with extra whimsy.

LOGOPHILE (noun): *a lover of words.*

The Basic Steps

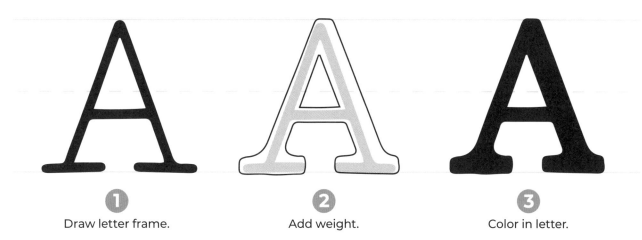

① Draw letter frame.

② Add weight.

③ Color in letter.

A B C D E F G
H I J K L M N
O P Q R S T U
V W X Y Z

a b c d e f g h i j
k l m n o p q r s
t u v w x y z

Simple Style Tip!

Make this style more playful by moving letters up and down
on the baseline and changing the slant of the letters.

Hello, sunshine

Letter Practice: Uppercase

TRACE: Trace each letter below to get familiar with the shapes and strokes.

A B C D E F G
H I J K L M N
O P Q R S T U
V W X Y Z

ADD WEIGHT: Now, add the varied weight to each letter frame on your own.

Letter Practice: Lowercase

TRACE: Trace each letter below to get familiar with the shapes and strokes.

a b c d e f g h i j
k l m n o p q r s
t u v w x y z

ADD WEIGHT: Now, add the varied weight to each letter frame on your own.

Let's Get Creative!

Sketchy Vintage

To really drive home the vintage vibe of Logophile, we're going to add sketchy and splotchy elements to the lettering to make it look like you've actually used a (somewhat old and finicky!) machine to type out the words. I thought this composition would look great on a sheet of paper coming out of a typewriter. You could try this effect on an invitation to a 1920s party, or simply to share a kind message as I've done here.

1
Start with a rough sketch of the letter frames for the phrase.

2
Begin to refine the sketch by adding contrast to the letter strokes. I went with the same variation as our original letters in this step.

You are lovely.

You are lovely.

3
Refine the sketch more. Once you fill in the letters with color, it is easier to see where you need to do some additional refinement.

4
Add some sketchy texture and splatters to create an inky, vintage typewriter look. (Save your almost-dried-out markers for this. They achieve this style well!)

You are lovely.

You are lovely.

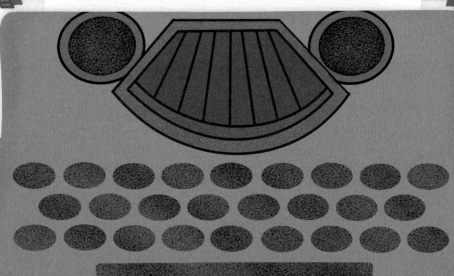

You are
lovely.

Swashy Flourish

A swash, also known as a tail, is a flourished part of an existing letter. For example, you can turn any serif or crossbar into a swash. When applied to Logophile, swashes lend the lettering style a more dramatic edge. The varying line weights of these particular swashes fill the words with whimsy. I was inspired by my love of literature—and the feeling of turning the last page of a great novel!—to use them in this book design. You could also try using them for monograms.

Plan your composition by arranging the letters in their exact base format, as shown.

Then, draw a simple sketch altering some letters to make them more playful. I opted to add several swashes in place of select serifs.

Time to refine the sketch! Start by adding contrast to the letter strokes. I used the same weight variation as our original letters.

For the last refinement, draw thinner swashes and add crescent shapes to some of the swash ends.

THE END

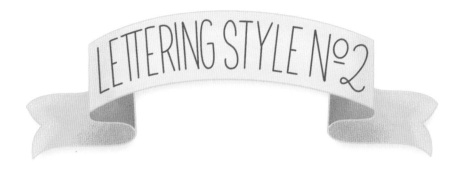

LETTERING STYLE № 2

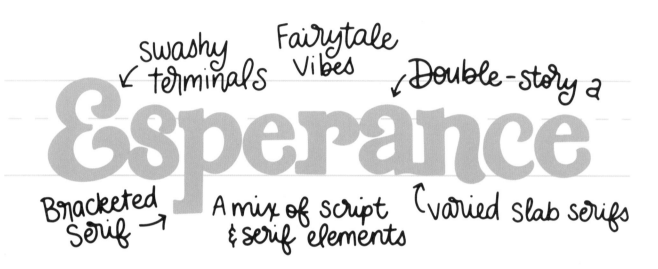

swashy
↙ terminals

Fairytale
Vibes

✓ Double-story a ↙

Esperance

Bracketed
Serif →

A mix of script
& serif elements

⌐varied slab serifs

This lettering style is a fairytale-inspired style that mixes elements of slab serifs and swashy scripts. These two seemingly incompatible features combine seamlessly because the swashes aren't too thin, so there is a good visual consistency across the whole style. I get serious Renaissance Faire fantasy feelings from the look of this style—imagine it adorning a wooden sign!

ESPERANCE (noun): *hope or expectation.*

The Basic Steps

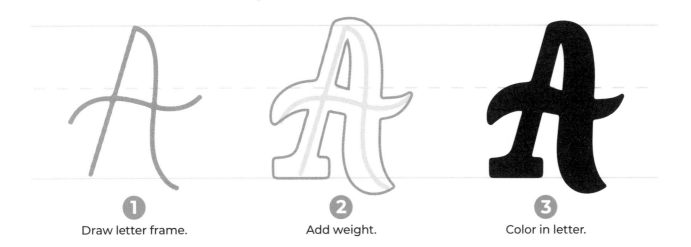

1 Draw letter frame.

2 Add weight.

3 Color in letter.

ABCDEFGH
IJKLMNOP
QRSTUV
WXYZ

abcdefghijk
lmnopqrst
uvwxyz

Simple Style Tip!

This style lends itself well to any customization you can dream up.
I love to add fun swashes to ascenders and descenders.

I → I hope → hope

Letter Practice: Uppercase

TRACE: Trace each letter below to get familiar with the shapes and strokes.

ADD WEIGHT AND SERIFS: Now, add the weight and serifs to each letter frame on your own.

Letter Practice: Lowercase

TRACE: Trace each letter below to get familiar with the shapes and strokes.

abcdefghijk
lmnopqrst
uvwxyz

ADD WEIGHT AND SERIFS: Now, add the weight and serifs to each letter frame on your own.

abcdefghijk
lmnopqrst
uvwxyz

Gradient Watercolor

Let's walk through the steps of a complete project in this style. I wanted to create a positive sentiment where words flowed into one another like a breath. For the sentiment itself, I was inspired by the name of the style. I opted for a colorful watercolor gradient as the fill. If you want to create a similar effect, make your final lettering in the form of very faint outlines that will disappear under the paint.

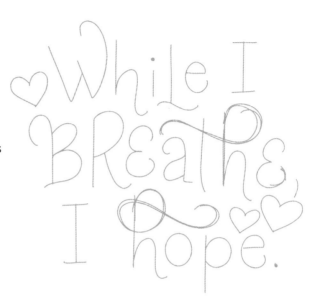

1 Start with a rough sketch of the letter frames. Add simple flourishes and hearts to fill empty space and create overall balance.

2 Begin to refine the sketch by adding contrast to the letter strokes and adding serifs and swashes.

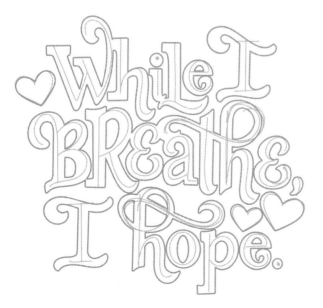

3 Refine the sketch further. Begin to add color and adjust letters as needed until you're happy with the final shape.

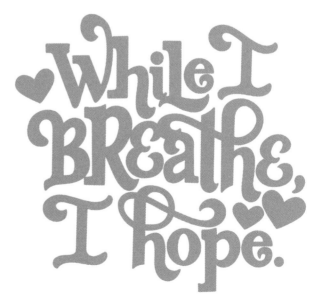

While I Breathe, I Hope.

Slight Slants

For this piece, I included slanted text and a spilling cup of tea. It can be a lot of fun to integrate a single image or icon into a composition. When you know what you want to include, and you know how many letters are in the words you want to use, you can really plan it out so that the image fits in with the words. In the final art, I added a 3D effect to the outline of each letter to make the letters look almost like cookie cutters.

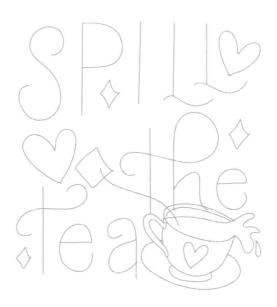

1 Draw simple guidelines for the composition. Notice that when lettering on a slant in this style, the letters should still sit straight up and down on top of the baseline, even though the baseline itself is at an angle.

2 Flesh out the letter frames by adding varied weights, serifs, and swashes. I love adding a ligature in the "th" combo. Remember, a ligature is when you join two letters together to form one unit.

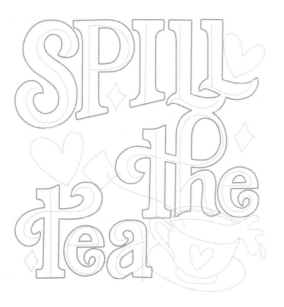

3 Refine the letters and illustration elements until you have a final working sketch. Using little dots, sparkles, and hearts is an easy way to fill empty spaces, which helps balance the artwork. Your eye for creating balance in your pieces will grow over time.

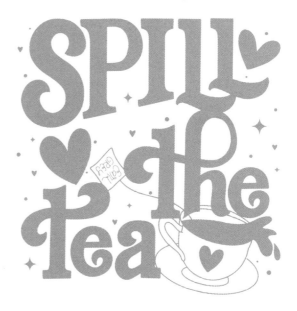

LETTERING STYLE № 3

monoweight
curvy details
Sans Serif

Bravado

↑ modern, clean aesthetic ↗

This lettering style is a monoweight script that's
modern and clean, yet still playful and fun!
The curved and wide shapes take up space almost
like they're asserting their confidence, matching the
vibe of the style's name. With different letters and
lines leaning either to the left or the right,
and sometimes staying centered, there is
a bit of buoyancy to the style too.

BRAVADO (noun): *a show of boldness.*

The Basic Steps

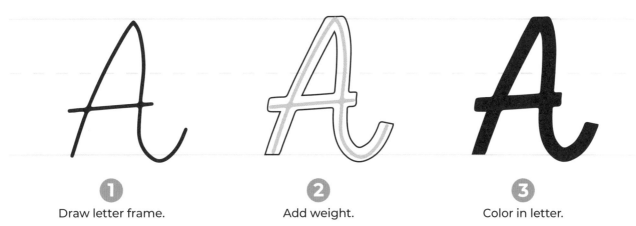

① Draw letter frame.

② Add weight.

③ Color in letter.

ABCDEFGH
IJKLMNOP
QRSTUV
WXYZ

abcdefghijk
lmnopqrst
uvwxyz

Simple Style Tip!

Change up the original style of various letters while staying within the Bravado aesthetic to add more character and personality.

A A a A R R n r

Letter Practice: Uppercase

TRACE: Trace each letter below to get familiar with the shapes and strokes.

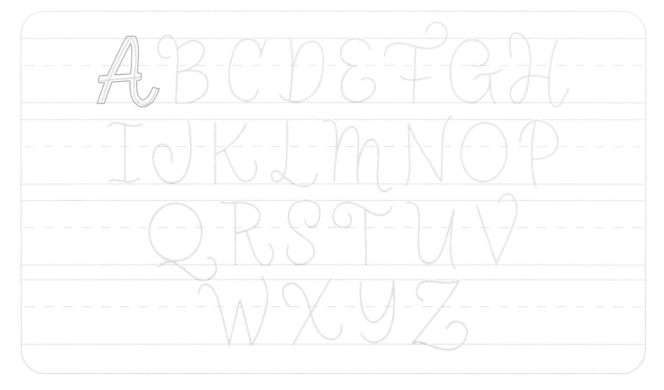

ADD WEIGHT: Now, add the even weight to each letter frame on your own.

Letter Practice: Lowercase

TRACE: Trace each letter below to get familiar with the shapes and strokes.

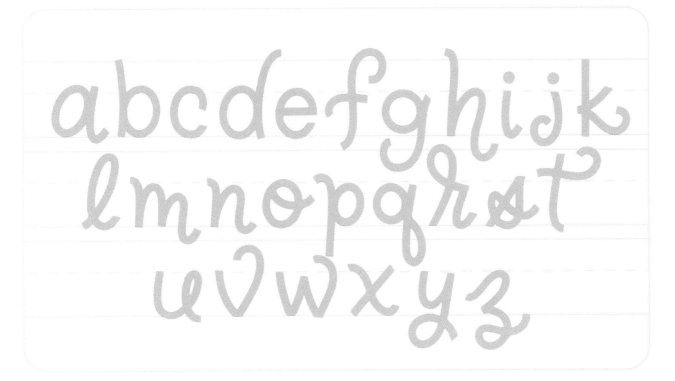

ADD WEIGHT: Now, add the even weight to each letter frame on your own.

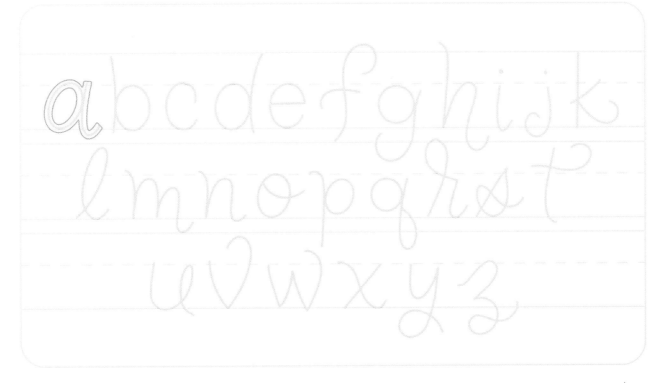

Winning Combo

For this message about an important duo, let's combine the Bravado style with the Esperance style (page 80). Since we are using two lettering styles, we can keep the overall design simple while still creating a playful, cute final piece of art. I tied the entire composition together near the end by incorporating hearts throughout, including a simple heart border. The colors really pop on the white background.

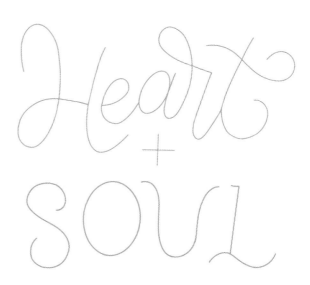

1

Start with a rough sketch of the letter frames. Keep in mind that the weights of your two chosen styles may be different, so the spacing between letters may need to be slightly different in each word.

2

Begin to refine the sketch by adding weight to all the letters. Follow the weight guidelines of each style or make them uniform— it's up to you!

3

Refine the sketch further until you're happy with the final letters. Sketch in simple illustrations and lettering details to balance out the composition and add unique character to the design.

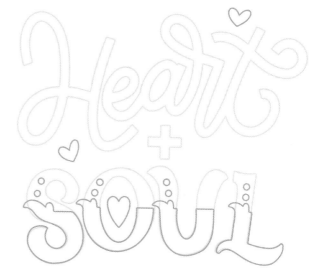

Heart + Soul

Combo Variation

I was so enamored of the previous style combo that I had to return to it a second time—this time, with Bravado and Moxie (page 128). Instead of having each word be a different color—which suited the sentiment of the previous piece—I made all the lettering here light yellow with white accents, because this message wants to be more cohesive, since it's a single statement. The words really stand out on a contrasting dark color background.

Draw the letter frames. Keep in mind that the weights of your two chosen styles may be different, so the spacing between letters may need to be slightly different in each word.

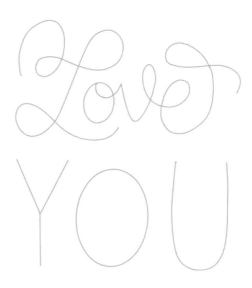

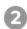

Flesh out the letter frames by adding weight and serifs as needed.

Refine the letters and add details. I included hearts, sparkles, and dots, as well as adding a second layer to my Moxie letters.

Love you

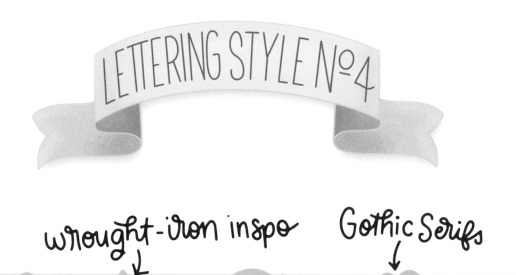

LETTERING STYLE Nº4

wrought-iron inspo

Gothic Serifs

TALISMAN

Decorative

Swash terminals

all Caps

This lettering style is an all-caps decorative serif inspired by Gothic wrought-iron work. I love the elaborate twists, turns, and knobs of wrought iron, so I integrated curves and little extrusions throughout the style. The letters bring to mind an elaborate crucifix one might use to fend off a vampire! It is an uppercase-only style, so it works splendidly for eye-catching monograms and makes a big impact wherever you apply it.

TALISMAN (noun): *an object thought to have magical powers and bring good luck.*

The Basic Steps

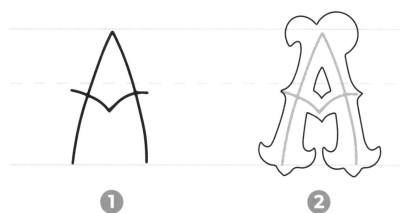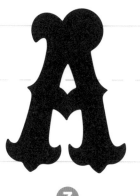

① Draw letter frame.

② Add weight and serifs.

③ Color in letter.

ABCDE
FGHIJK
LMNOP

QRSTU
VWXYZ

Simple Style Tip!

This style may look intimidating to draw, but the Gothic serifs are composed of easy arcs and shapes. Here's a breakdown for you.

Letter Practice: Uppercase

TRACE: Trace each letter below to get familiar with the shapes and strokes.

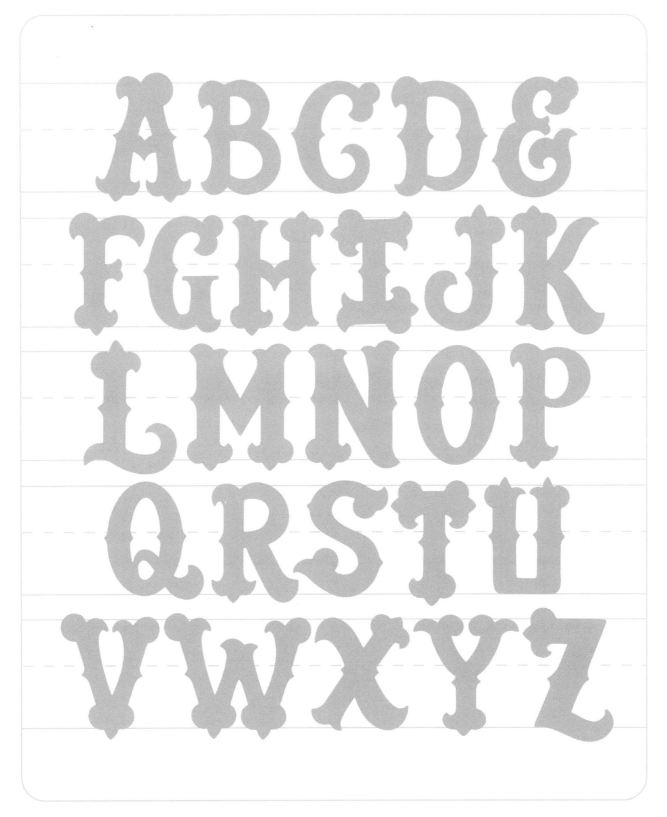

Letter Practice: Uppercase

ADD WEIGHT AND SERIFS: Now, add the weight and serifs to each letter frame on your own.

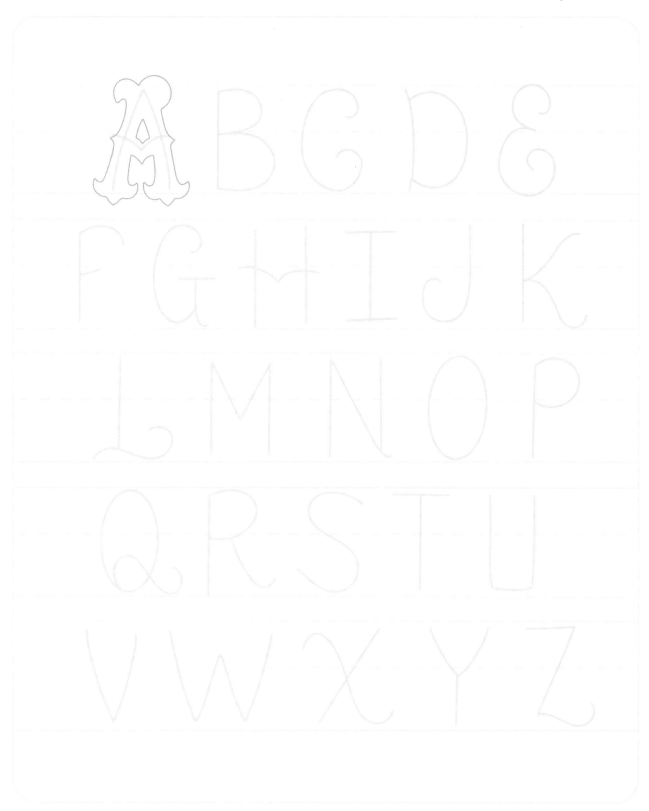

Embellished Letters

Because Talisman is so thick and weighty, it is a great style in which to incorporate artistic details right inside the letters themselves. I chose to repeat the same set of two hearts and a flower in each letter, sometimes more than once for balance. Then I tied these details in with the overall composition by incorporating flowers, leaves, and hearts around the words. Notice how often I repeat some illustrations within the same piece—this is a time-saver and a great way to keep artwork consistent and balanced.

 Start with a rough sketch of the letter frames. I opted to change the letter "E" two of the three times to a more traditional uppercase style instead of using the extra-rounded style of Talisman's "E."

 Begin to refine the sketch by adding weight and serifs to all the letters.

❸ Finalize the lettering and sketch out some illustrative elements around it. I went with folksy florals, hearts, butterflies, dots, and other simple elements. You can learn to draw these in chapter 5!

Letter Replacement

Think outside the box! A letter doesn't always have to be a letter. Certain letters, like "O"s, really lend themselves to being replaced with other object or icons. That's because an "O" is, typically, just a circle, and there are tons of circular objects out there—or objects that read as roughly circular, like a heart. Something similar can be said for simple vertical letters like a capital "I." Once you start imagining letter replacements, you will be sure to come up with lots of ideas!

1

Draw the letter frames.
For this composition, I replaced the letter "O" in the word "LOVE" with a heart, which has the added bonus of shortening the width taken up by this longest word in the sentiment, equalizing the whole thing.

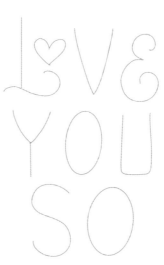

2

Add weight and serifs. Don't forget to add a little extrusion to the heart so that it feels cohesive with the letters.

3

Refine the letters and add illustrations. I wanted the leaves and vines incorporated here to be lush but not so thick as to overwhelm the lettering. The final effect is really achieved through the coloring.

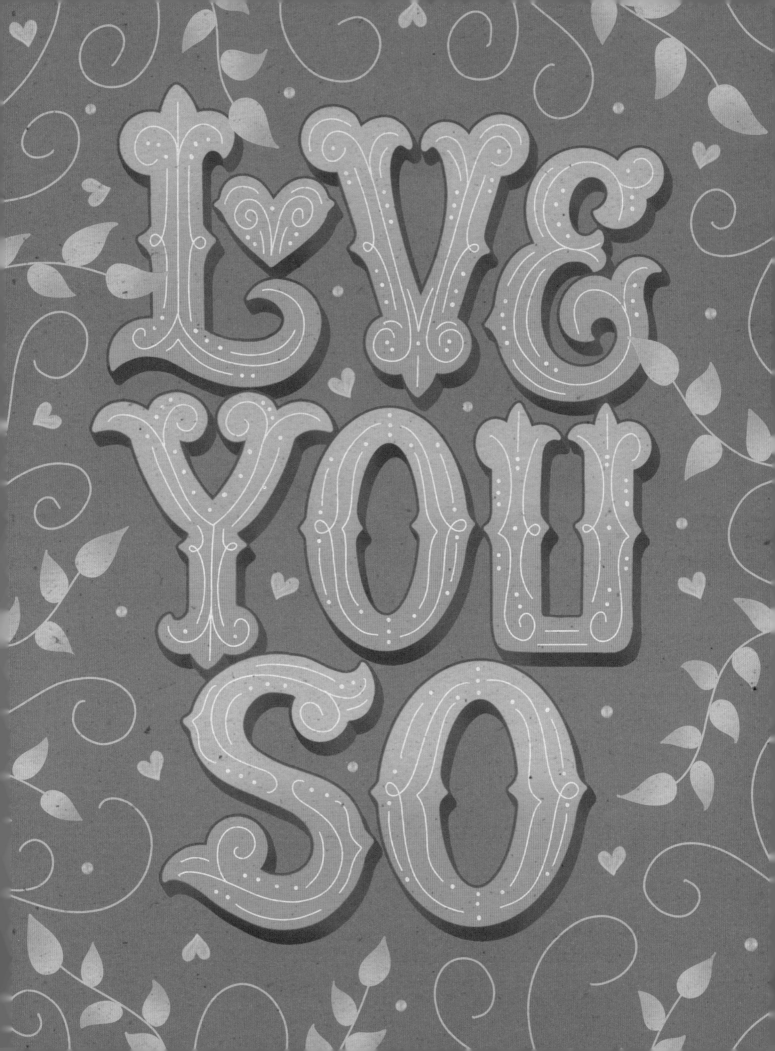

LETTERING STYLE №5

Unconventional use of CAPS

teardrop terminals

ETHEREAL

Modern Hairline Serifs

High-Contrast weight variation

This lettering style is a high-contrast style that's part serif, part script, and uses capital letters unconventionally—it is meant to be composed with a mix of uppercase and lowercase letters than seem to fit together along their curves. The weight variation between the bulk of each letter and its demure serifs and thin swashes lets the style have a big impact while still remaining delicate and, well, ethereal.

ETHEREAL (adjective): *light, delicate, and heavenly.*

The Basic Steps

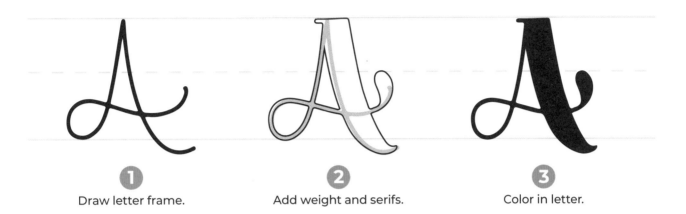

① Draw letter frame.

② Add weight and serifs.

③ Color in letter.

Simple Style Tip!

Look for ways to add fun ligatures (lines connecting two letters) to your artwork!
"Th"/"th" is the most common, but the "fi" ligature is another gorgeous option.

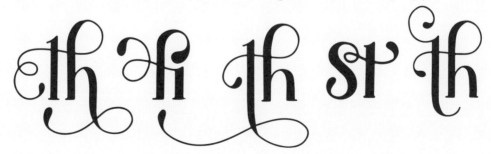

Letter Practice: Uppercase

TRACE: Trace each letter below to get familiar with the shapes and strokes.

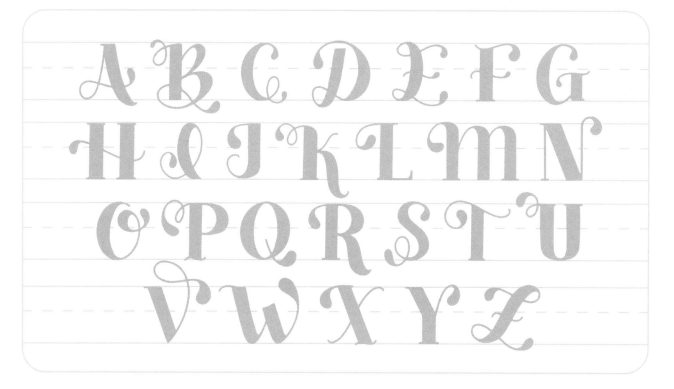

ADD WEIGHT AND SERIFS: Now, add the weight and serifs to each letter frame on your own.

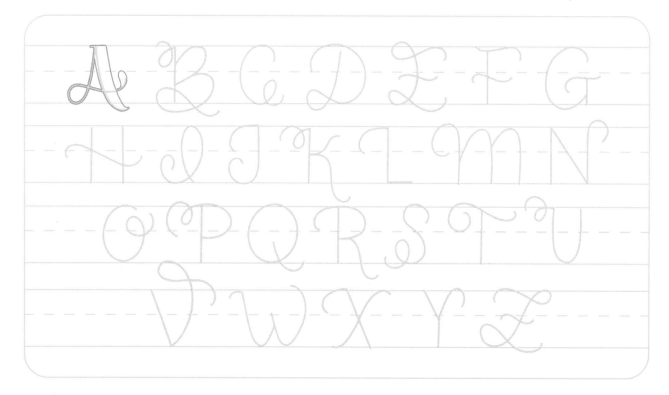

Letter Practice: Lowercase

TRACE: Trace each letter below to get familiar with the shapes and strokes.

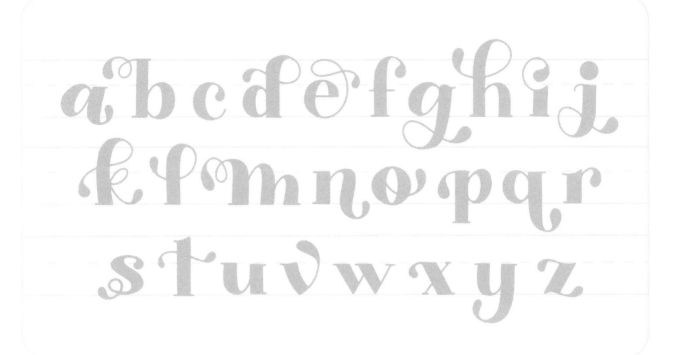

ADD WEIGHT AND SERIFS: Now, add the weight and serifs to each letter frame on your own.

Swirly Simplicity

The Ethereal lettering style is so fun on its own—the letters themselves do a lot of the vibe work. For this composition, I added just a few dots, sparkles, hearts, and complementary curving lines to keep the focus on the style and flourishes. A white hairline within each letter gives the letters just a bit more dimension. And, of course, the colors practically glow on the white background. This is a great style for a fancy invitation or a thank-you card.

1 Start with a rough sketch of the letter frames. Include some uppercase and lowercase letters and flourishes that look visually appealing.

2 Begin to refine the sketch by adding weight and serifs to all the letters, as well as teardrop terminals to the ends of the flourishes.

3 Finalize the lettering and sketch out some illustrative elements. I added simple circles, dots, sparkles, hearts, and a little coordinating linework.

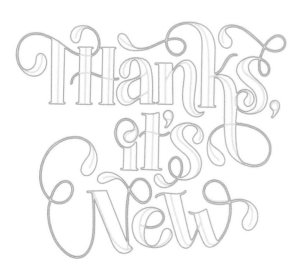
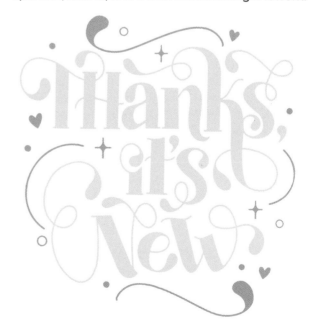

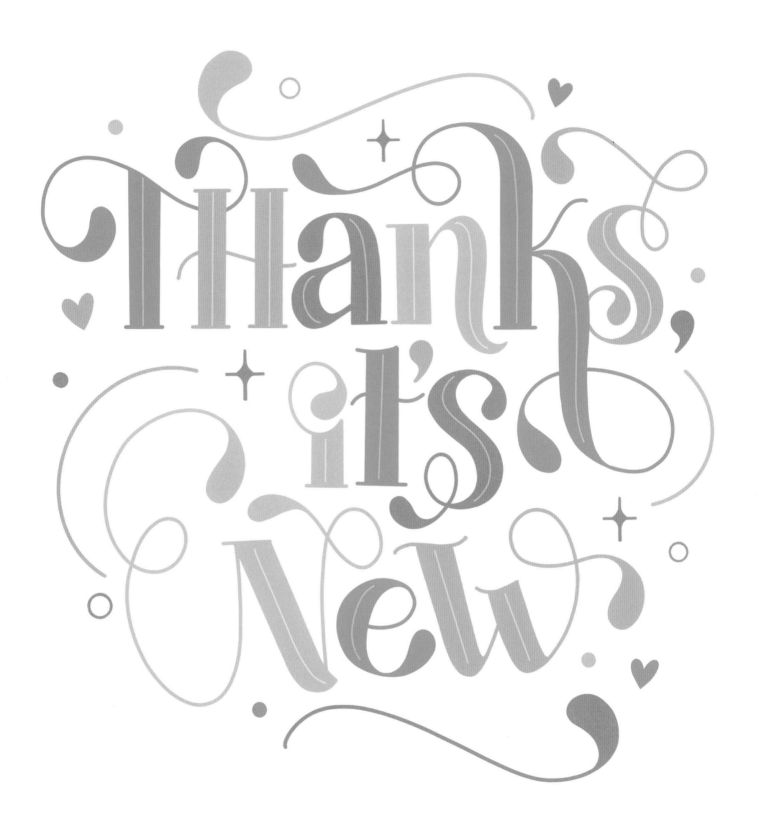

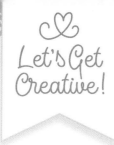

Elegant Flow

The focus of this piece is definitely the flourishes. They structurally surround the letters at the top, bottom, and sides without making the message disappear. This composition also features several ligatures, like "th" and "fi," which really help the words flow together. After establishing the design, I finished it with a chalky, painterly effect to ground the concept. This is a great aesthetic to copy for any chalk signage!

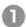

Draw the letter frames. I started with a few simple flourishes, knowing I'd add more in my next round of sketching. I opted for all lowercase letters for this piece of artwork.

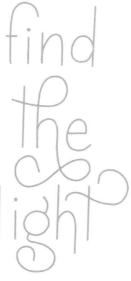

Add flourishes with teardrop terminals. Sketch out the serif placements.

Add weight and final serifs. Refine the letters and add illustrations.

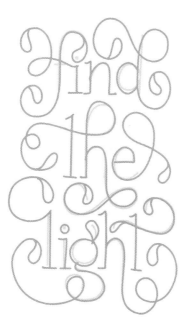

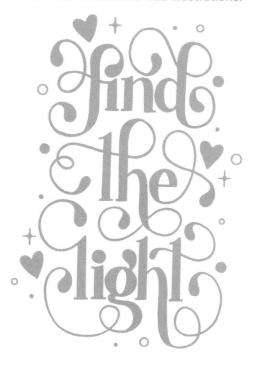

find the light

LETTERING STYLE № 6

romantic details
high contrast
KISMEt
mix of serifs + swashes
Extra-high x-height

This lettering style is a high-contrast, romantic style that's a playful blend of classic and modern. It has an intentionally top-heavy look because the letters' x-height is taller than in most styles. The classic serifs ground the style, and the curviness adds romanticism even when there's not a literal heart in the design—but if you include a lowercase "i," you can have that too!

KISMET (noun): *destiny; fate.*

The Basic Steps

1 Draw letter frame.

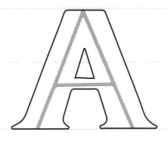

2 Add weight and serifs.

3 Color in letter.

ABCDEFG
HIJKLMN
OPQRSTU
VWXYZ

abcdefg
hijklmn
opqrstu
vwxyz

Simple Style Tip!

This lettering style works as well for all-caps lettering
as it does for a traditional uppercase and lowercase blend.

KISMET

Letter Practice: Uppercase

TRACE: Trace each letter below to get familiar with the shapes and strokes.

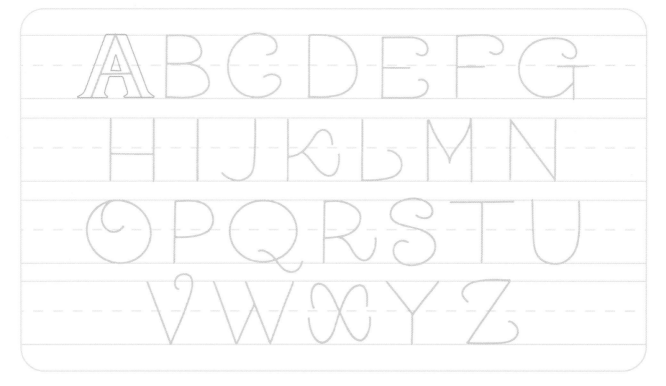

ADD WEIGHT AND SERIFS: Now, add the weight and serifs to each letter frame on your own.

Letter Practice: Lowercase

TRACE: Trace each letter below to get familiar with the shapes and strokes.

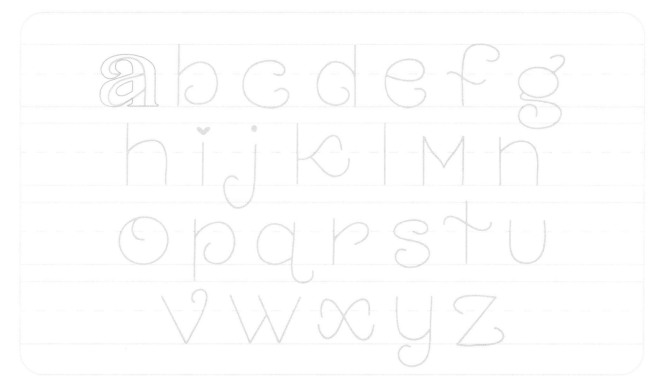

ADD WEIGHT AND SERIFS: Now, add the weight and serifs to each letter frame on your own.

Stitched Stack

This simple sentiment stack of one word on top of another is hefty because of how well the letters block around each other and fill the space—you can see how the flourish of the "C" and the top of the "T" in the word "cute" flow upward into the territory of the word "meet." I applied an appliqué look to the letters in the form of a shadow and a line of stitching dots around every letter, giving it a folksy feel.

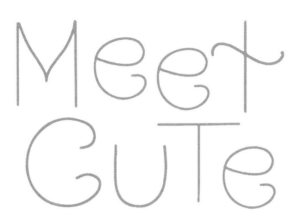

 1

Start with a rough sketch of the letter frames. I opted to add an uppercase letter "T" in "cute."

2

Begin to refine the sketch by adding weight, serifs, and swashes. My goal in this step is to fill space and create balance.

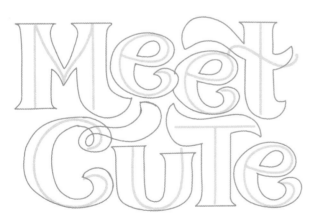

3

Refine the lettering and sketch frame of florals, hearts, and vines. The illustrations should also help create balance in the piece.

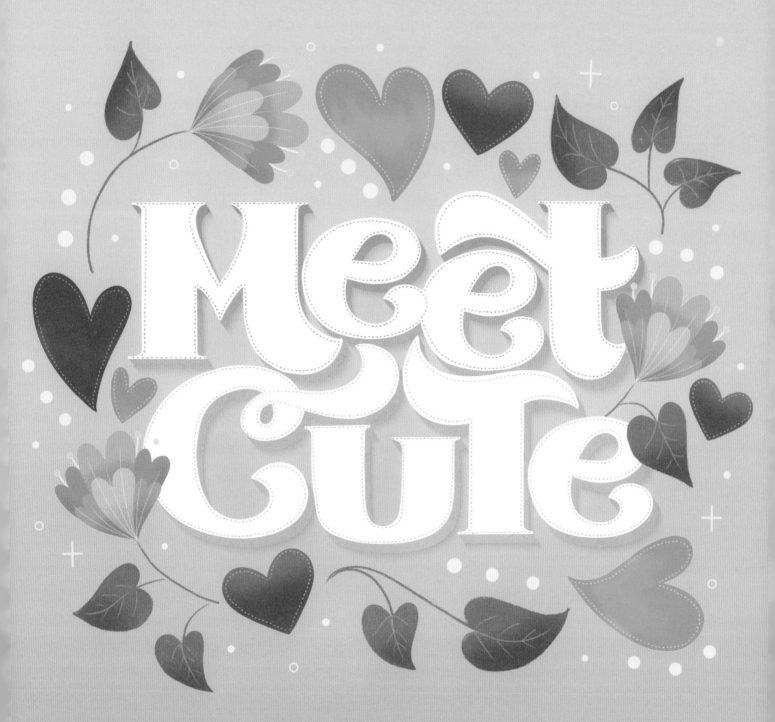

Deco Combo

This is a great example of how you can completely change a final composition in the middle of working on it. I started with just the word "rest," but, as I was working, I decided to add the more directive statement "Let Yourself" at the top—in a different lettering style. I chose a faux calligraphy; you could also use Bravado (page 88) or the foundational script style (page 42). In terms of decorative choices, I used the thickness of the letters as an opportunity to introduce art deco detailing.

Draw the letter frames. This is a fat style, so make sure to leave room between the frames for ample weight.

Add weight and serifs.

Add simple leaves around the letters.

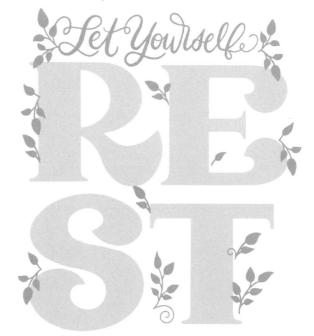

Let Yourself REST

no weight contrast

Sans (no) Serifs →

Ameliorate

Super-low crossbars

This lettering style is a monoweight sans serif ideal for adding lettering to illustration-heavy artwork. Because it is so delicate and relatively unadorned, it allows the eyes to rest within a busier composition. The whole style seems to "sit" extra low due to the low placement of the crossbars and other intersection points—giving the opposite effect to what you saw in the previous style, Kismet (page 112).

AMELIORATE (verb): *to make or become better.*

The Basic Steps

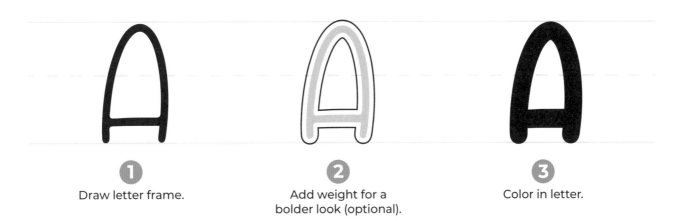

1 Draw letter frame.

2 Add weight for a bolder look (optional).

3 Color in letter.

ABCDEFGHIJ
KLMNOPQR
STUVWXYZ

aabcdefggh
ijklmnopqr
stuvwxyz

Simple Style Tip!

Use this minimalist style as a base to create unique floral-inspired serif lettering where the added serifs are flowers.

Letter Practice: Uppercase

TRACE: Trace each letter below to get familiar with the shapes and strokes.

A B C D E F G H I J
K L M N O P Q R
S T U V W X Y Z

DRAW: Now, draw the letters on your own!

Letter Practice: Lowercase

TRACE: Trace each letter below to get familiar with the shapes and strokes.

aabcdefggh

ijklmnopqr

stuvwxyz

DRAW: Now, draw the letters on your own!

Lettered Frame

This is a great example of how Ameliorate can be used when the focus is on the illustration, not the lettering. The words act like a frame or border, with the illustrated leaves and flowers partially bursting out of it. For this kind of composition, you really want to take your time to sketch out the exact placement of the letters so that the final effect looks symmetrical and polished.

Focus on sketching the hourglass first, since the illustration is the key to this piece. Use a compass and ruler for the frame outline if you want it to be precise.

Add lettering to the sketch. Erase and redo as many times as you need in order to get the lettering symmetrical and balanced.

Sketch out the floral illustrations around the hourglass. I opted to make the illustration an exact mirror image to the left and right of the center.

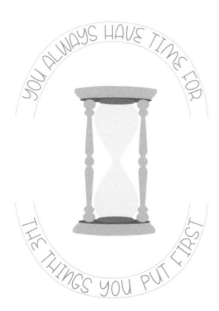

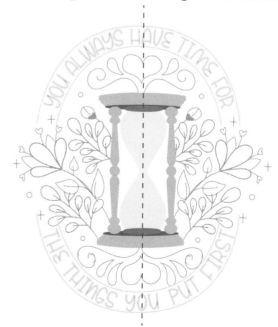

YOU ALWAYS HAVE TIME FOR THE THINGS YOU PUT FIRST

Framed Lettering

Now let's completely flip the concept of the previous piece of art and instead have an illustrated frame around the words! This is a great choice when you have a longer sentiment you want to feature, and, because Ameliorate is such a minimal style, it truly lends itself to wordiness without losing legibility. I loved taking direct inspiration from the quote to choose the illustrated details for this composition.

1

With a longer quote, plan how you want the lettering to look first. Make the attribution a mix with capital letters to differentiate it from the quote.

"I can be perfectly happy by myself. With freedom, books, flowers, and the moon, who could not be happy?"
– OsCaR WiLDE

2

Sketch various leaves to create a whimsical frame.

3

Sketch in a few more illustrations. I went with a moon, a book, and a heart. You can fill in small empty spaces with stars, flowers, and fireflies at the end.

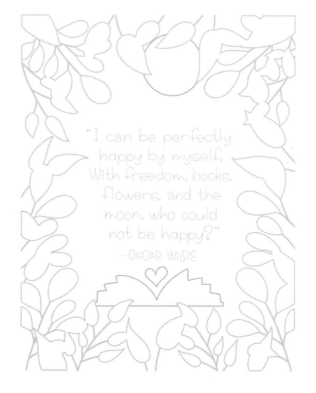

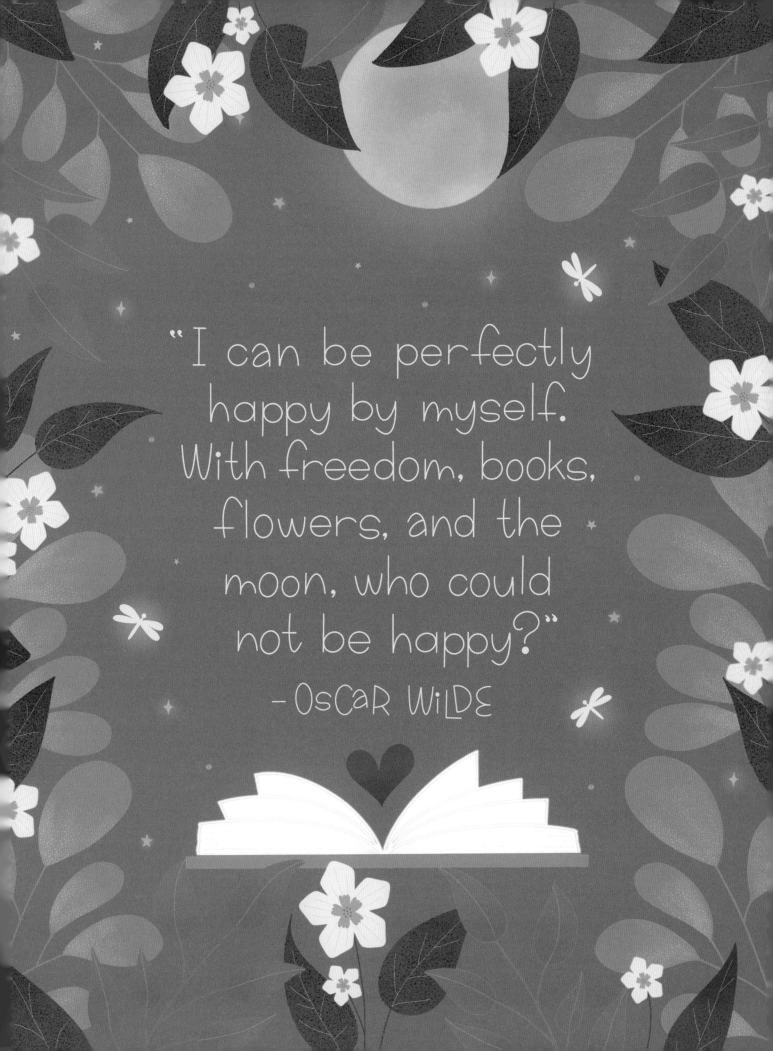

"I can be perfectly happy by myself. With freedom, books, flowers, and the moon, who could not be happy?"
- OsCAR WiLDE

LETTERING STYLE Nº 8

Tuscan Gothic Serifs + Swashes

Moxie

↖ mix of no + low-contrast letters ↗

This lettering style is a mix of low-contrast and no-contrast letters with Tuscan Gothic serifs and swashes. Unlike Talisman (page 96), it comes with a lowercase alphabet, which makes it somewhat more versatile. Its weightiness and flared details give it a unique and spunky feel. Moxie is one of my go-to lettering styles. I love to combine traditional elements with whimsical edits that make it feel more playful!

MOXIE (noun): *courageous spirit; determination; perseverance.*

The Basic Steps

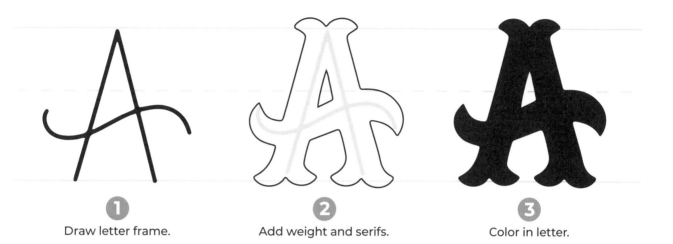

1 Draw letter frame.

2 Add weight and serifs.

3 Color in letter.

ABCDEFG
HIJKLMN
OPQRSTU
VWXYZ

abcdefghij
klmnopqrs
tuvwxyz

Simple Style Tip!

Check out how changing something as simple as the crossbar
in various ways can alter the overall look of a letter.

H H H H H H

Letter Practice: Uppercase

TRACE: Trace each letter below to get familiar with the shapes and strokes.

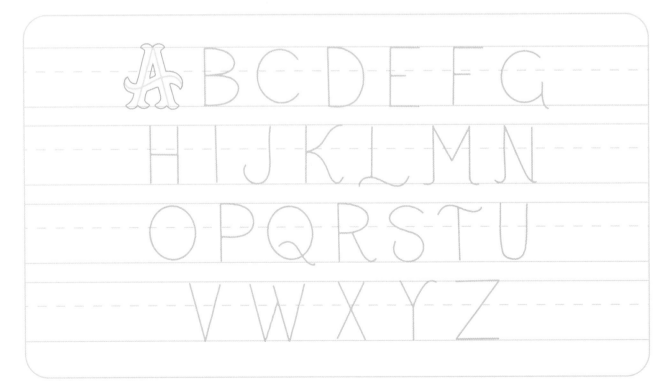

ADD WEIGHT AND SERIFS: Now, add the weight and serifs to each letter frame on your own.

Letter Practice: Lowercase

TRACE: Trace each letter below to get familiar with the shapes and strokes.

abcdefghij
klmnopqrs
tuvwxyz

ADD WEIGHT AND SERIFS: Now, add the weight and serifs to each letter frame on your own.

abcdefghij
klmnopqrs
tuvwxyz

Contrasting Details

This composition sticks to an almost completely uniform letter size and all uppercase letters throughout. But it's not boring, because of the contrasting details! The first two words get a simple dot decoration, but the emphasized word—"crown"—gets a bigger dot decoration as well a dip-sleeve effect with extra flourishes and color. You can achieve a lot with these kinds of differing details. This piece also benefits from the letters within the individual words all having a slightly different baseline so they feel like they have some movement.

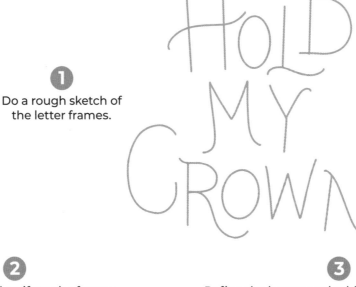

1 Do a rough sketch of the letter frames.

2 Add weight and serifs to the frames.

3 Refine the letters and add simple illustrations. I added a crown and sparkles. Then I added all the contrasting details you see (and described above).

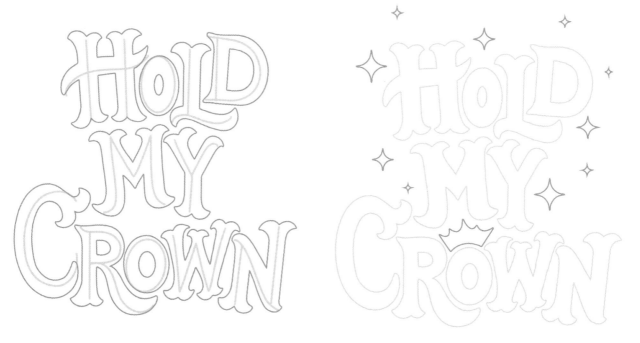

HOLD MY CROWN

Triple Combo

Remember that general rule I mentioned about mixing only two or (maximum) three styles? Let's see how three works! For this piece, I mixed Moxie with Esperance (page 80) and a foundational sans serif (page 26), altered to smoosh into a heart shape. I can't resist lettering a good book pun—which is why I chose this sentiment—so I applied an overall clothbound hardcover book texture to the entire page. You can practically touch it!

 1

Begin with a rough sketch of your composition. I chose to keep the first and last (top and bottom) words in the Moxie style for balance and vary the other two words.

2

Flesh out the letter frames by adding varied weights and serifs where applicable, depending on the style.

3

To fill space and create balance, add dots, hearts, and sparkles.

ISBN
thinking
ABOUT YOU
YOU

LETTERING STYLE Nº9

↙ *All caps* *Curvy Serifs* ↘

HALCYON

Fun crossbars *Gothic decorative details*

This lettering style is an all-caps style featuring curvy serifs, fun crossbars, and Gothic-inspired details. The letters are tall rather than wide, which gives a feeling of strength, power, and even a little awe, and the style's tendency to use straight lines in the main body of each letter lends it sturdiness. But the quirky crossbars and little swooping, curving serifs and swashes keep it from feeling too overbearing or aggressive.

HALCYON (adjective): *happy, carefree, prosperous, and peaceful.*

The Basic Steps

1

Draw letter frame.

2

Add weight and serifs..

3

Color in letter.

ABCDE
FGHIJK
LMNOP

QRSTU
VWXYZ

Simple Style Tip!

Here's a visual breakdown of how to draw the curvy serifs and Gothic-inspired details for this style.

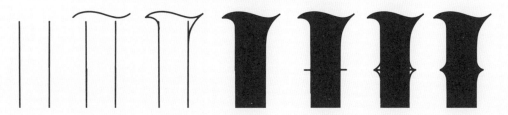

Letter Practice: Uppercase

TRACE: Trace each letter below to get familiar with the shapes and strokes.

A B C D E

F G H I J K

L M N O P

Q R S T U

V W X Y Z

Letter Practice: Uppercase

ADD WEIGHT AND SERIFS: Now, add the weight and serifs to each letter frame on your own.

Enclosed Lettering

For this piece, I was inspired partially by crystal balls but also by magic 8 balls. You can see the magic 8 ball influence in the way the white words glow out from the dark, swirling blue background. When finishing the piece, I added an additional fog-like swirl around the whole thing to really emphasize the feeling of enchantment. And, as a final detail, there are tiny stars decorating the letters themselves!

Start with a rough sketch of the letter frames within a circle. Make sure to leave enough space between the line of the circle and the edges of the letters.

Begin to refine the sketch by adding weight and serifs to all the letters.

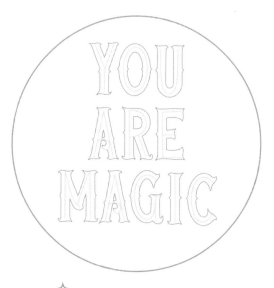

Finalize the lettering and sketch out the base of the crystal ball. Add a variety of stars and sparkles to balance the piece.

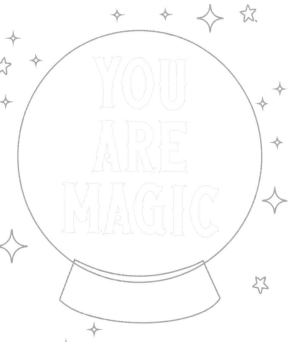

YOU ARE MAGIC

Let's Get Creative!

Floating Lettering

Unlike the previous art, where the words were contained within a frame, this art features the words floating on an open background, with illustrated elements tied to and surrounding the lettering. This felt like the right choice for the theme of a road trip, where the open road is ahead of you. I went with a dark blue for the letters—a bit like asphalt—and light blue for the background, reminiscent of sky. Within this composition, I included a location marker, some scattered "x"es (as in "X marks the spot"), mountains, a travel path, and hearts (of course)!

1

Draw the letter frames.

2

Add weight and serifs.

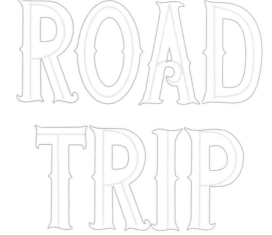

3

Refine the letters and add illustrations that go well with the travel theme.

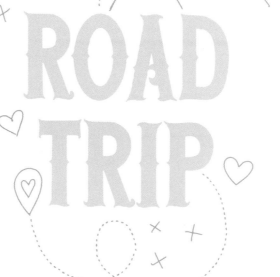

ROAD TRIP

LETTERING STYLE Nº 10

SWITCHEROO

← (Almost) Anything goes! →

This lettering style is a mixed-up decorative style that playfully breaks the rules! You want serifs? You've got 'em—sometimes. You want long flourishes? You can spot some! You want straight lines, curvy lines, wide letters, skinny letters, ball serifs, slab serifs, and hearts? It's all here. And, because this style is so eclectic, it lends itself well to simply shrinking individual letters to create a lowercase effect whenever you want.

SWITCHEROO (noun): *a surprising variation.*

8 Tips for Creating Mixed-Lettering Artwork

Let's break all the rules to create an incredibly playful look. You can mix and match different lettering styles to create a balanced yet fun piece with a ton of character! Mixed lettering is one of my signature styles. It's doodle-y, colorful, imperfect, and, most importantly, me.

ONE: Mix different foundational styles together (serif, sans serif, script).

TWO: Vary the size of each letter.

THREE: Vary the color of each letter.

FOUR: Vary the weight of each letter (monoline, bold, calligraphic, thick, thin).

FIVE: Add different styles of decorative elements on each letter (dots, lines, textures).

SIX: Add shadows and dimension to only some letters.

SEVEN: Mix lowercase and uppercase letters in an unconventional way.

EIGHT: Change each word's lettering style instead of each letter.

As you begin this style on your own, start simple. Draw one letter in a dozen or more ways. Bonus points if you do this exercise for the whole alphabet!

A B C D E F G H
i J K L M N O P Q R
S T U V W X Y Z

Letter Practice: Mixed Letters

TRACE: Trace each letter below to get familiar with the shapes and strokes.

ABCDE
FGHiJK
LMNOOP
QRSTU
VWXYZ

Letter Practice: Alternate Letters

TRACE: Trace each letter below to get familiar with the shapes and strokes.

aBCDe
FGHiJK
LMNOP
QRSTU
VWXYZ

Eclectic Embellishment

If you're a maximalist, then this is the art inspo for you. The name of the game with this composition is that not only is each letter a different style, but each letter also has a different tiny doodle detail inside of it! Hearts, dots, lines, sparkles, stars—if you can doodle it, you can add it. And if you don't think you can doodle it, I beg to differ—check out chapter 5. By keeping the letters roughly the same size and sticking to a three-color palette, the piece remains grounded while not compromising its eclecticism.

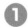

Start with a rough sketch of the letter frames.

Begin to refine the sketch by adding weight and serifs to the letters as needed. Think of it like a puzzle. You can fill the empty spaces with the serifs and details you add.

Add doodles into and around the letters to add interest and character.

HAPPY MAIL

Mixed Messaging

I love this piece because it ended up looking like the hearts were little bubbles of foam rising to the top of an expertly crafted latte. The color balance is really important for this piece—the hearts and the main word, "latte," are multicolor, whereas the other words in the middle are monochromatic to act as a kind of anchor. I chose to use a slightly tweaked and more script-like version of Bravado (page 88) for the middle words.

1

Draw the letter frames.

2

Add weight and serifs to the appropriate letters.

3

Add a coffee cup or mug in whatever style you like, plus a bunch of hearts rising in the top half of the design.

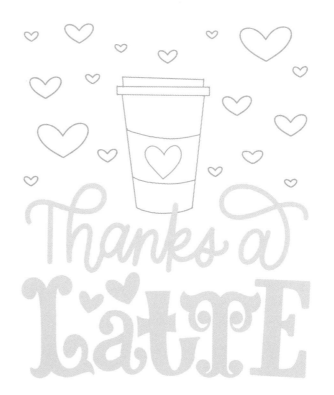

Thanks a Latte

Creative Customizations

As I promised in the introduction to this chapter, here are some tips for creatively customizing any and all of these lettering styles to make them your own! I used various letters from the 10 styles we just learned as examples here.

Change the Letter Weight

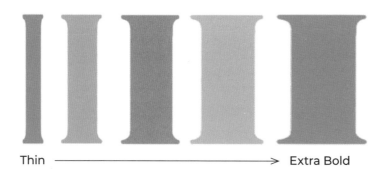

Thin ⟶ Extra Bold

Change the Letter Contrast

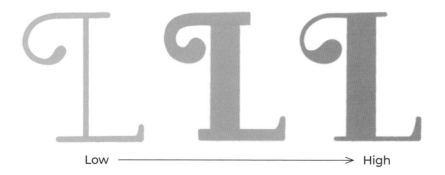

Low ⟶ High

Change the Lettering Style

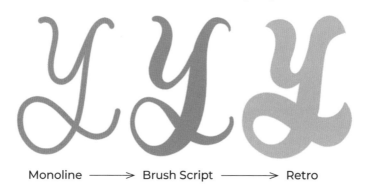

Monoline ⟶ Brush Script ⟶ Retro

Add In-Line Lettering Details

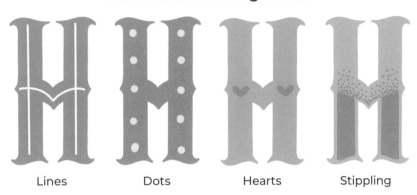

Lines Dots Hearts Stippling

Add Dimension

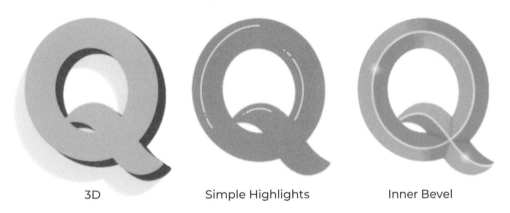

3D Simple Highlights Inner Bevel

Switch Up the Serif Style

From Gothic to slab to decorative, the options are many!

DRAW

CHAPTER 4:
Delightfully Easy Illustrations

Even when you've mastered a lettering style, it can
feel intimidating to then try to compose art around
a lettered word or phrase. Allow this chapter to be like
a craft supply closet for you, where you can pick and choose
from dozens of ready-to-go doodles, flourishes, butterflies,
seasonal motifs, flowers, and more to mix into your art.
Practice the elements by tracing them or following the
provided steps, grab what you're inspired by, and know
that the supply closet will never run out!

Doodles

Here is a full page that you can trace and use as ideas for adding illustrations for your lettering projects. Every design is super simple and easy to reproduce freehand.

Hearts & Stars

Follow these simple steps to make elaborate hearts,
and get inspired by the many star shape options!

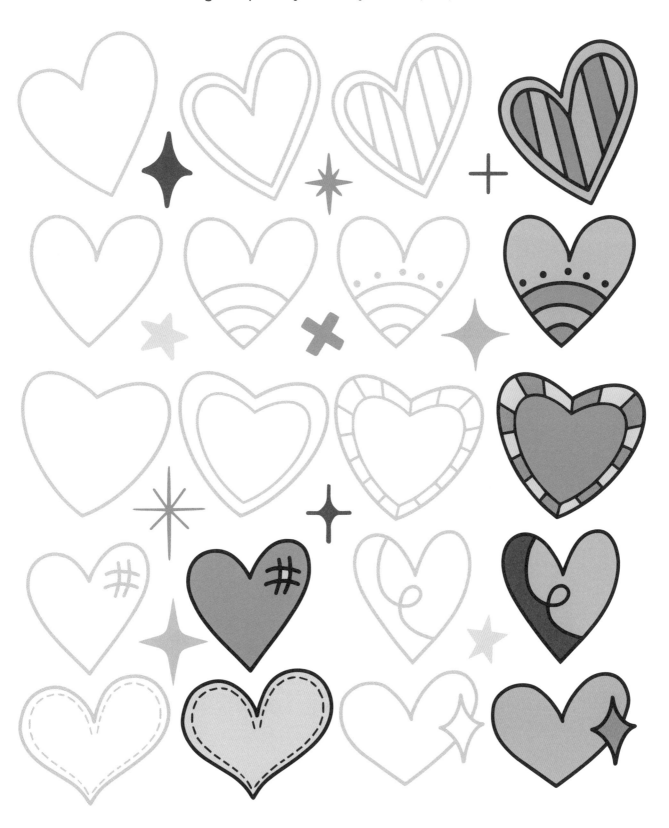

Flourishes

Flourishing is one of my favorite ways to add a playful elegance to my work. There are endless ways to draw flourishes, but here are a bunch to get you started. Trace them with a pencil several times in a row, then shift your pencil to a blank page to practice them.

Leaves & Stems

Can you draw a stick frame and add a few basic shapes to it? Of course you can!
Add a splash of color and a few simple details to create these folksy cuties.

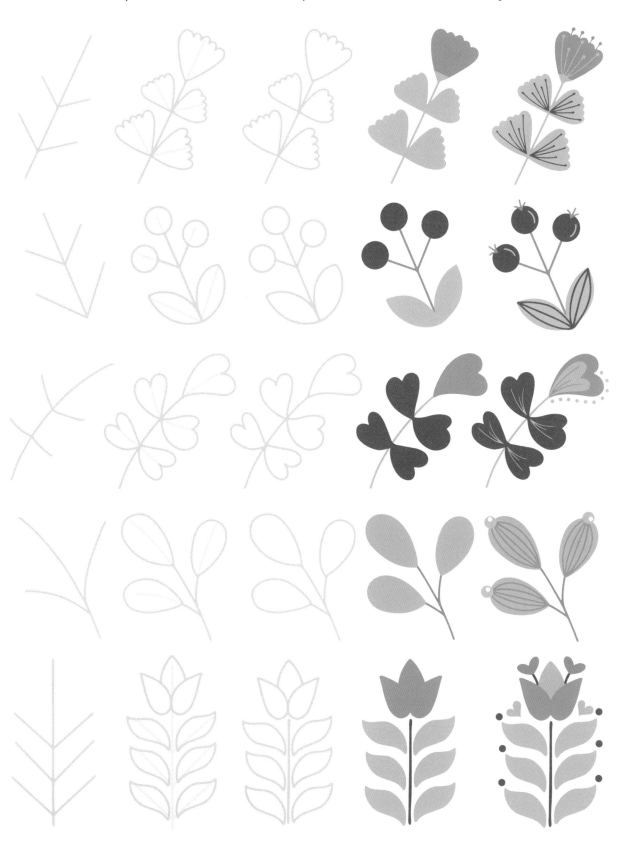

Butterflies

Even the most basic shapes become playful when they are stacked and colored! Each of these adorable butterflies can be created in a few simple steps. First, draw the ellipse shapes. Second, connect the ellipses with lines. Then, erase any extra pencil lines. Finally, add color and details. I used a lot of hearts, dots, and other simple illustrations to decorate the wings.

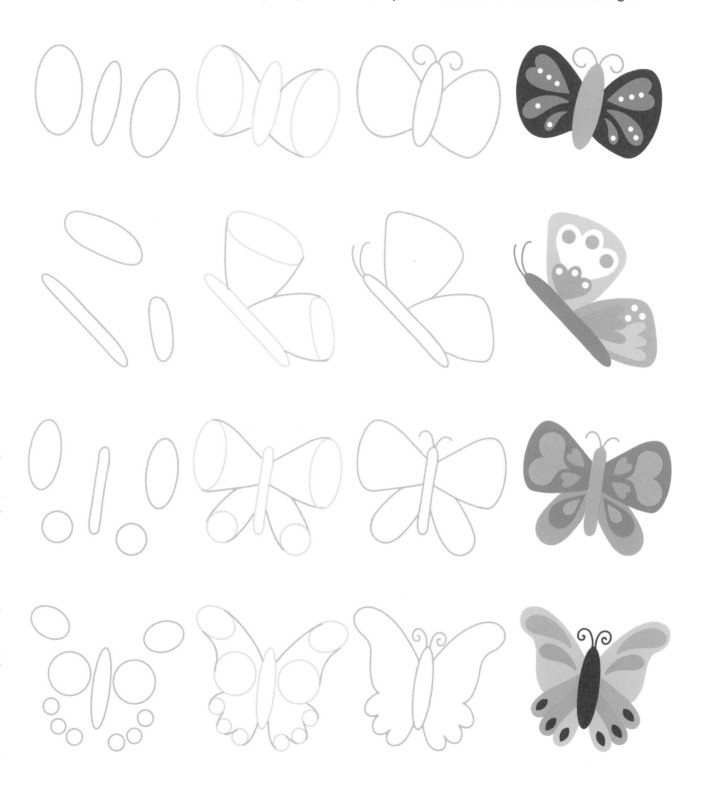

Seasonal Motifs

Let's draw one easy illustration for each season of the year: classic winter holly, the cutest spring floral bud, a summery tropical monstera leaf, and an autumn acorn.

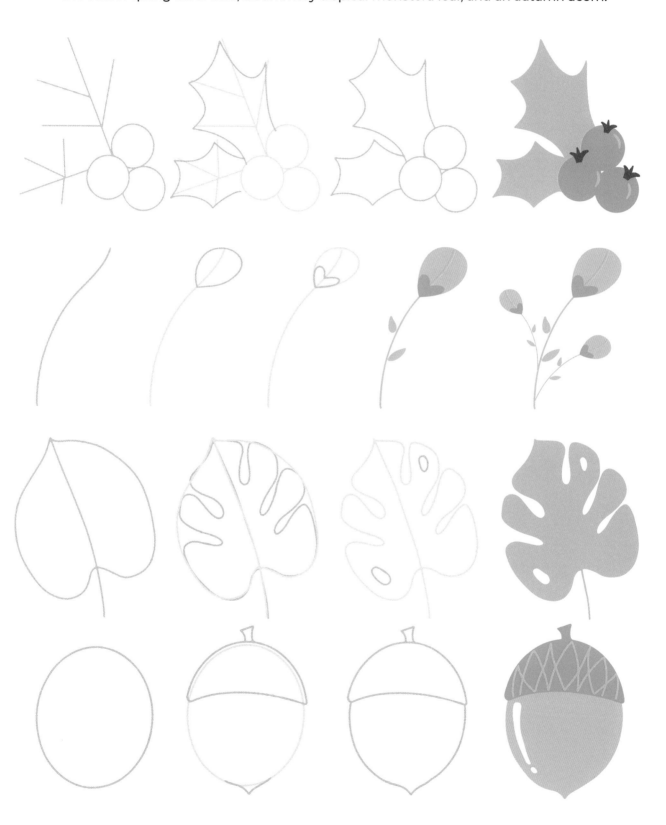

Folk Art Cherry Blossom

1

Draw a five-petal flower with scalloped petal ends.

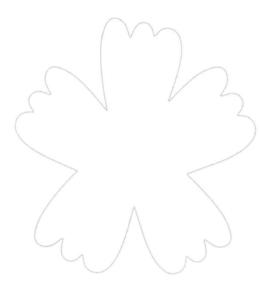

2

Add hearts and a stem.

3

Draw a cluster of plus signs for the center and add three lines to each petal.

4

Color it in! Gel pens work well for white details over color.

Folk Art Tulip

 With pencil, draw a tulip-like flower with three stubby petals.

 Add a second three-petal flower and a stem. Erase extra lines.

 Add lines, dots, and stamens with concentric hearts.

 Add color. Don't be afraid to play with nontraditional colors!

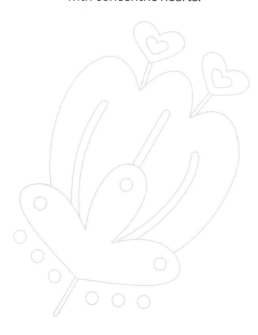

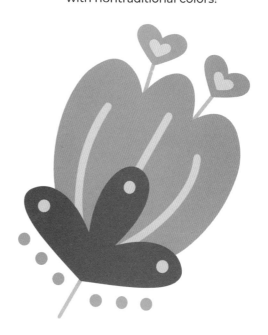

Folk Art Fleur-de-lis

With pencil, draw an elongated three-petal flower with a second one inside it.

Add water droplet shapes and a stem. Erase extra lines.

Add dots, mini flowers, stamens, and a heart.

Make it colorful!

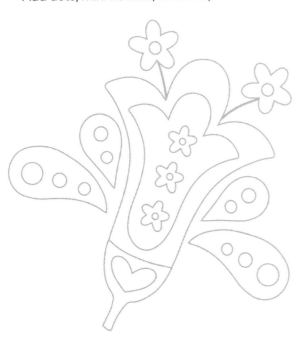

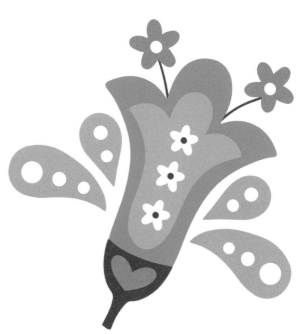

Folk Art Pollen Puffs

Draw a bubbly four-petal flower
with a rounded bottom.

Add an arched line through
the flower and a stem.

Add hearts, lines, and stamens
with puffy-flower tops.

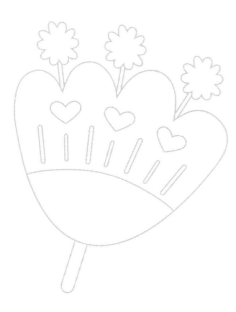

Add color, such as two shades of pink
and matching green stems.

Folk Art Abstract Flower

With pencil, draw a big heart with a stem. Add two smaller hearts below it.

Add a three-petal shape on top of the big heart. Erase extra lines.

Draw an upside-down teardrop on the middle petal. Add dots and mini hearts.

Make it pretty with color!

Folk Art Droopy Daisy

Draw a bubbly three-petal flower in profile view.

Add four stamens to the center of the flower and a stem at the bottom.

Add lines and dots to the flower and hearts and dots near the stem.

Color it in!

Folk Art Tiger Lily

 1

With pencil, draw a three-petal flower with pointy petals and a stem.

 2

Add a second layer in the same shape. Add two stamens with tulip tops. Erase extra lines.

 3

Add butterfly wings, a body, and antennae, then hearts and dots.

 4

Add color!
Make sure the butterfly pops out.

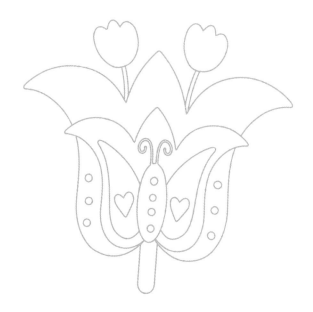

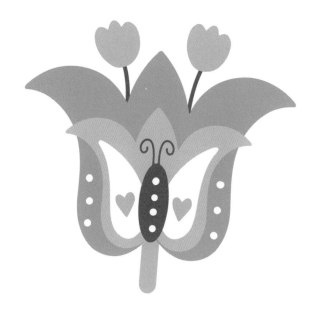

Folk Art Heart Bloom

Draw a flower with a scalloped top
and two leaves.

Draw two concentric hearts in the flower
and add four flower-topped stamens.

Add leaf lines, lines around the hearts,
and dots in the stamen flowers.

Color it in! Try shades of green and blue
for the main flower and leaves.

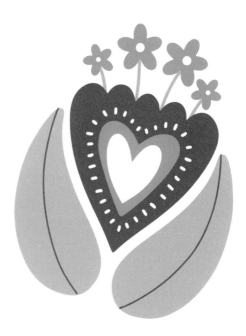

Folk Art Cone Flower

 Draw a three-petal flower with long, rounded petals in profile view.

 Add a stem and two heart-topped stamens.

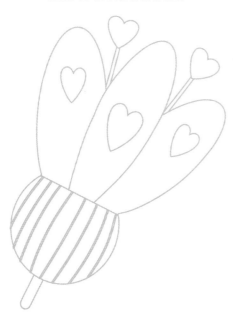 Add hearts to the petals and lines to the flower base.

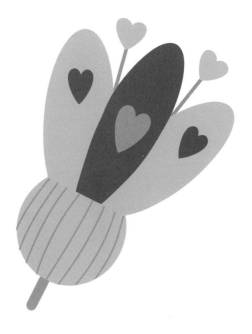 Add color!

Folk Art Pretty Petals

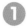 Draw a funky five-petal flower.

 Add a band at the base of the petals and four long, flower-topped stamens.

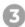 Add dots on the flower base and to the stamen flowers.

 Make it colorfully creative! I went with a rainbow scheme for the petals.

PROJECTS

CHAPTER 5:

Playful Projects

Armed with your knowledge of many lettering styles,
familiarity with color, and wide array of illustration elements,
you're ready to tackle the full-blown projects.
In this chapter, I share six diverse projects suited for
physical media in a variety of styles and vibes. Feel free
to re-create them in your own colors, with a fresh
lettering-style choice, or with different words or phrases
instead of the ones I used. By the time you've completed
a few of these projects, you'll have developed true
confidence in your potential as a lettering artist!

Patchwork Style

STYLES USED: basic block sans serif

For this first project, we'll use a super-simple block sans serif lettering in order to express a super-simple message. The simplicity of the lettering makes this a great exercise to warm up with or to return to if you're feeling unmotivated to tackle one of the more difficult or finicky lettering styles.

SUPPLIES

- Paper of choice (mixed-media paper is recommended)
- Pencil
- Eraser
- Ruler
- Markers and gel pens

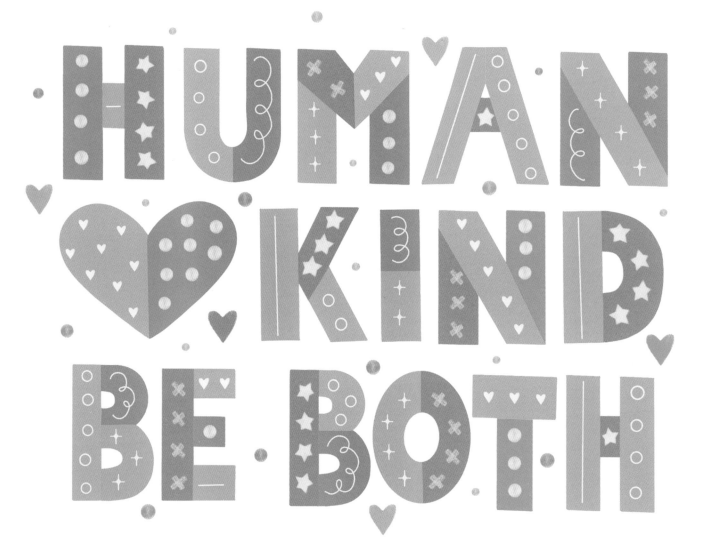

STEP 1: Sketch.
Lightly sketch out your letter frames, leaving room to turn them into bold block letters. Envision fitting your letters inside a rectangular shape for this step. Use a ruler to draw some temporary guidelines.

STEP 2: Add weight. Using your letter frame sketch as a guide, add weight to create thick block letters. Try to keep the stroke weight the same throughout the entire phrase. There are no serifs.

STEP 3: Refine. Erase any extra pencil lines, including the temporary framing box. Make any other adjustments you feel are necessary to the letters before proceeding.

HUMAN ♥ KIND BE BOTH

STEP 4: Add color. Color in the letters with markers using a color-block style. Choose four colors for the piece, repeating them as a pattern. I went with dark pink, light pink, dark yellow, and light blue. Depending on the length of your phrase, anywhere from four to ten colors will work nicely.

STEP 5: Add details. Using a white gel pen, add simple doodles to each block of color. Alternate various types of cute doodles on repeat until you finish the phrase (I used eight different doodles).

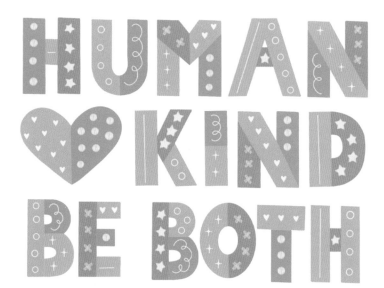

STEP 6: Add doodles. To give the piece an even more playful look, use your markers to add more doodles to the space surrounding the letters. Keep it simple with colorful hearts and dots.

Level Up
Your Lettering

Try spreading out the lettering and words more and incorporating more elaborate folk art flowers and butterflies.

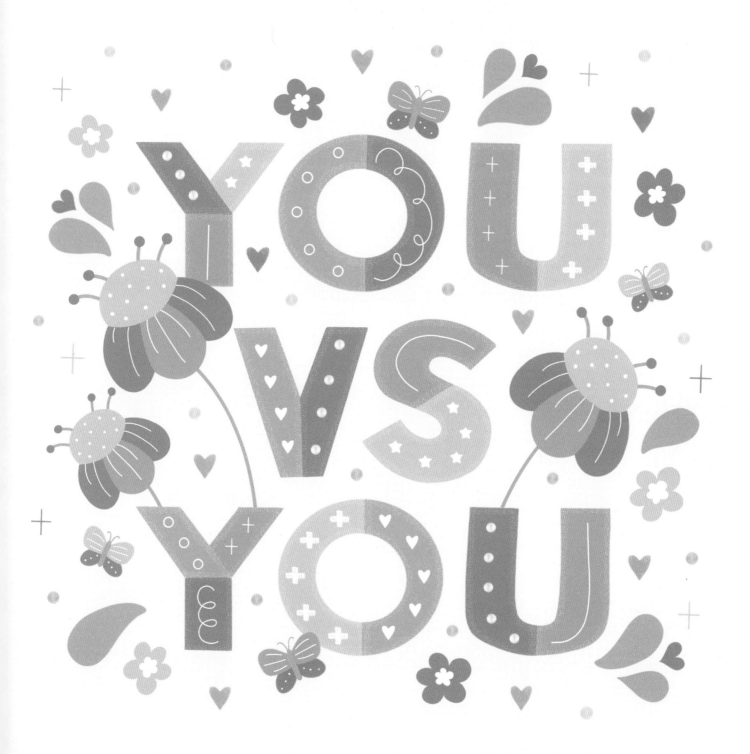

Project Two:

Mixed Lettering

STYLES USED: mixed lettering with some Switcheroo letters

I shared detailed tips for creating mixed lettering back in chapter 3 (see page 145). Now, we'll create a lettering project in this style from start to finish. We'll also take a closer look at something you've surely noticed in other pieces up to this point in the book: 3D shadow effects to add dimension!

SUPPLIES

- Paper of choice (mixed-media paper is recommended)
- Pencil
- Eraser
- Markers
- White gel pen

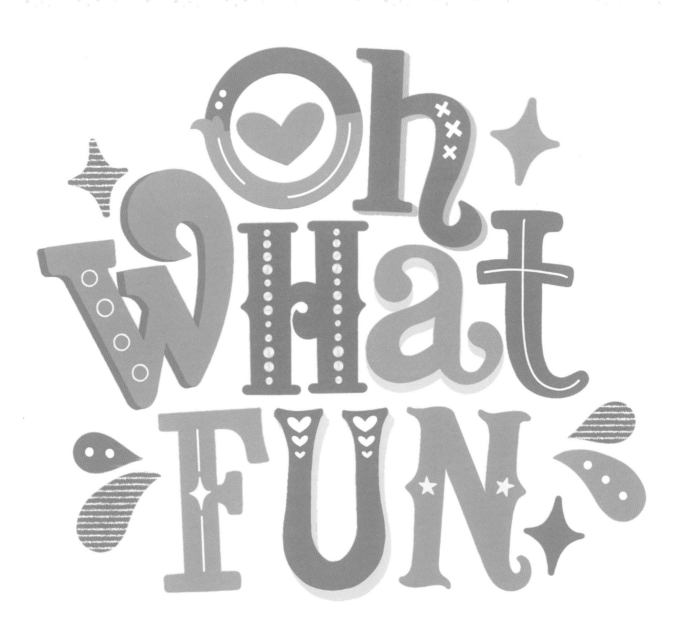

How to Add Letter Dimension

Before we jump into the lettering for this project, you'll need to know how to add simple dimension to your letters. To keep it easy, there's no need to worry about a consistent light source for this project.

1 Complete a letter in any style—the whole letter, not just the frame.

2 Choose a direction for the dimension. Draw short lines at the same angle on all the letter's corners and bends.

3 Connect the short lines with longer lines, following the shape of the original letter.

4 Fill the dimensional shadow area with color.

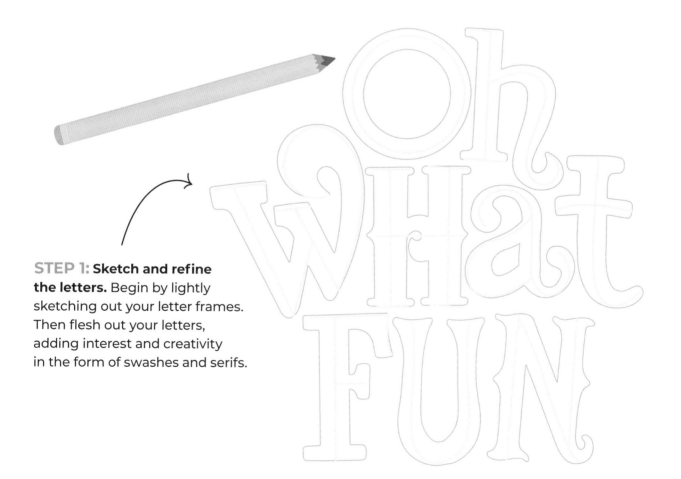

STEP 1: Sketch and refine the letters. Begin by lightly sketching out your letter frames. Then flesh out your letters, adding interest and creativity in the form of swashes and serifs.

STEP 2: Add color.
Erase any extra pencil lines if needed. Add color to your letters, filling each one in with a solid shade.

STEP 3: Add shapes and dimension.
Balance out your artwork by adding a few extra shapes around the letters and dimension to select letters. I added some sparkles, droplets, and a heart.

STEP 4: Add white details.
Finally, use a white gel pen to add in-line details to your letters and some of the illustrated shapes.

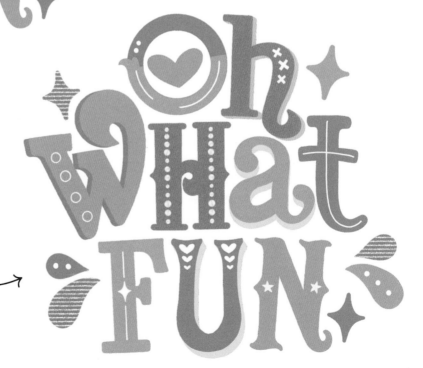

Level Up
Your Lettering

Take this style to the next level by getting even more detailed
with the linework, doodles, textures, and dimension.

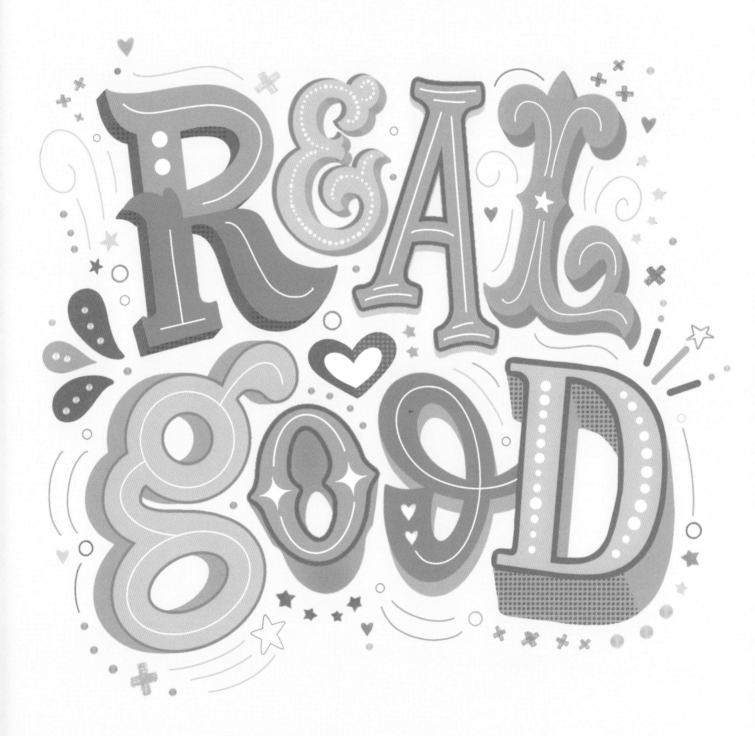

Modern Folk Art

STYLES USED: **Halcyon**

I'm most inspired by the Scandinavian style of folk art, which is heavily focused on nature and botanical elements. It's common to use happy and serene elements like birds, animals, butterflies, plants, and flowers in this style. Many artists also use geometric shapes, such as hearts or circles, lines, vines, and dots. The illustrations can feel almost childlike, and you can get creative with patterns and colors. For example, blue flowers may not be common in nature, but they're right at home in modern folk art. I love the idea of creating things that are unexpected and dreamlike!

SUPPLIES

- Paper of choice (mixed-media paper is recommended)
- Pencil
- Eraser
- Markers
- White, yellow, and green gel pens

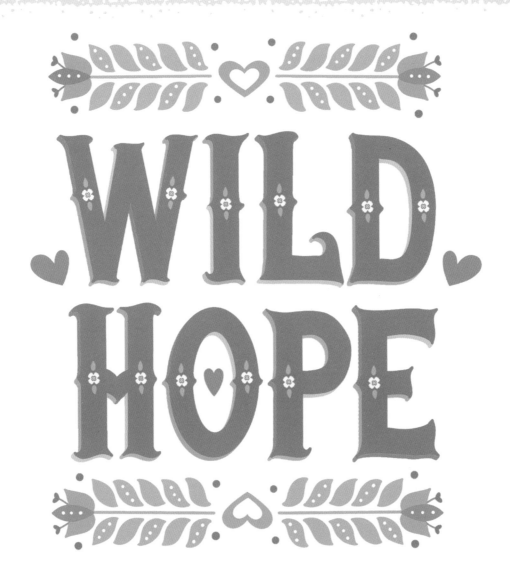

What Makes Modern Folk Art?

There are four key elements of my personal modern folk art style:

Color: If you study examples of Scandinavian folk art, most (but not all) of them are very colorful, so I tend to use bright, fun, and bold color palettes in these pieces.

Imperfect symmetry: Symmetry is a main element in a lot of Scandinavian folk art. I try to create balance and fill the space around the letters using not-quite-perfect symmetry.

Simplicity: Keep your illustrations simple in shape and add basic details all over (I use a lot of lines and dots). Flat illustrations are typical. I don't (usually) use textures or shadows in this type of artwork.

Whimsy: The definition of "whimsical" includes words like "playful" and "fanciful." Keep those in mind as you work on this kind of art!

STEP 1: Sketch the letters. Begin by lightly sketching out your letter frames. Add weight and serifs to the letters.

STEP 2: Add color. Color the letters in with a periwinkle shade. Add basic dimension to all the letters as shown in the previous project (page 179). Fill the dimensional areas with alternating colors as shown.

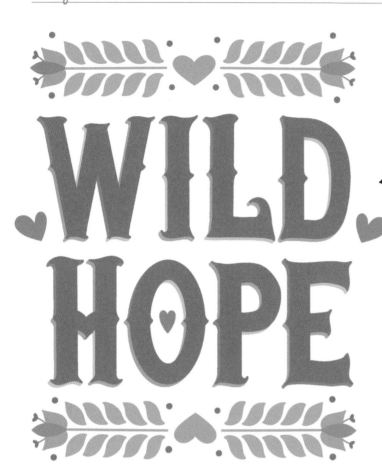

STEP 3: Add drawings. Add illustrations in the form of folksy flowers, hearts, and dots. The top and bottom illustrations in my piece are mirror images of one another. I use a lot of repeated elements like this in my folk art designs.

STEP 4: Finish with details. Use a white gel pen to add dots and a concentric heart to the floral illustrations. Use white, yellow, and green gel pens to add small flower details to the letters. Do you see how when simple elements are stacked and repeated, it makes the overall piece look far more intricate than it is? A few more dots and hearts always do wonders!

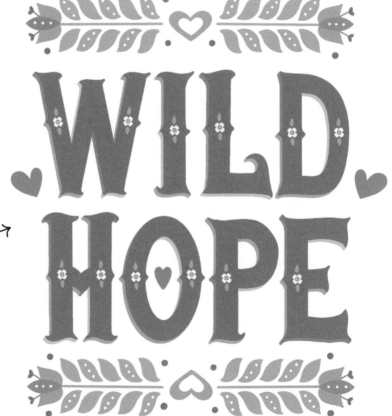

Level Up
Your Lettering

Take this style to the next level by combining the mixed lettering from the previous project with modern folk art lettering elements. I opted for a tropical theme for my lettering, which helped me focus on specific kinds of leaves and florals for the illustrations. Wouldn't this be fun in ultrabright neon colors?

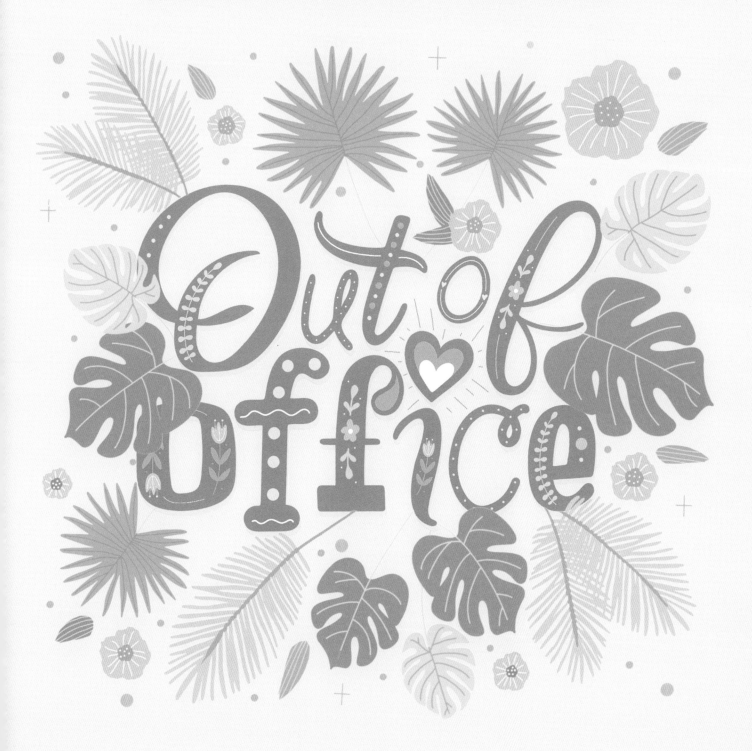

Abstract Symbol

STYLES USED: Logophile, slab serif, monoline sans serif, monoline script, calligraphic script

For this piece, the idea was to heavily focus on an ampersand—which is simply a beautiful symbol—but also to infuse it with meaning by surrounding it with a lot of love. I read this piece to myself as if I'm saying "love & love & love & love . . ." But maybe you process it differently! Feel free to choose your own pairing of symbol and words.

SUPPLIES

- Mixed-media or watercolor paper
- Pencil
- Eraser
- Paintbrush
- Colored pencils, watercolors, markers, and waterproof pens and gel pens

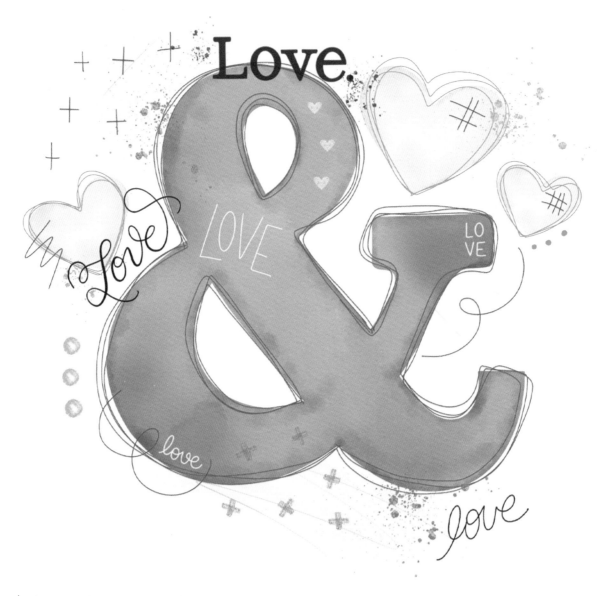

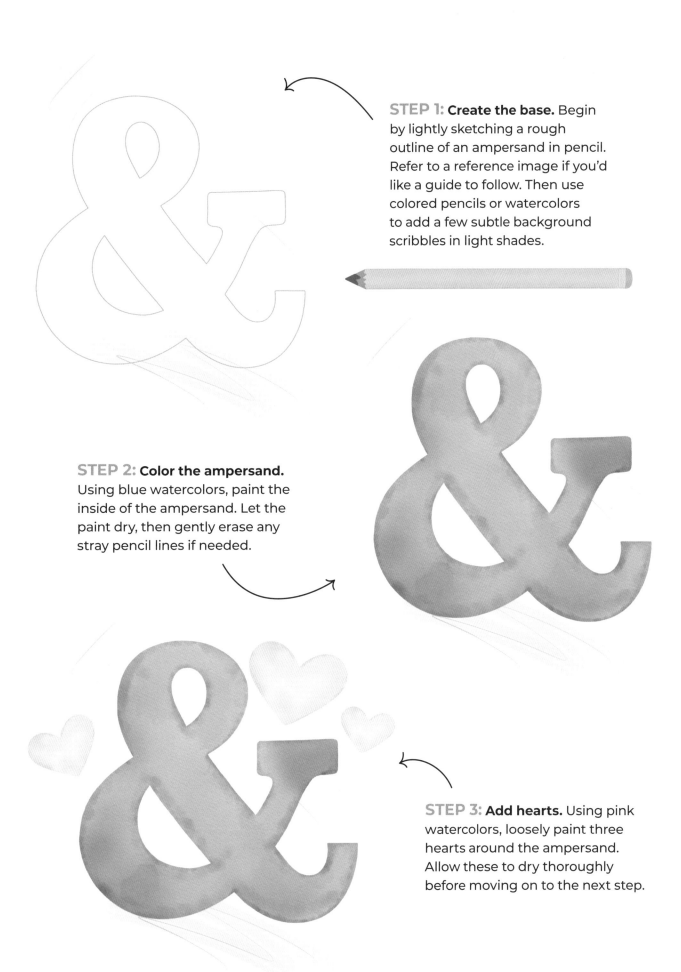

STEP 1: Create the base. Begin by lightly sketching a rough outline of an ampersand in pencil. Refer to a reference image if you'd like a guide to follow. Then use colored pencils or watercolors to add a few subtle background scribbles in light shades.

STEP 2: Color the ampersand. Using blue watercolors, paint the inside of the ampersand. Let the paint dry, then gently erase any stray pencil lines if needed.

STEP 3: Add hearts. Using pink watercolors, loosely paint three hearts around the ampersand. Allow these to dry thoroughly before moving on to the next step.

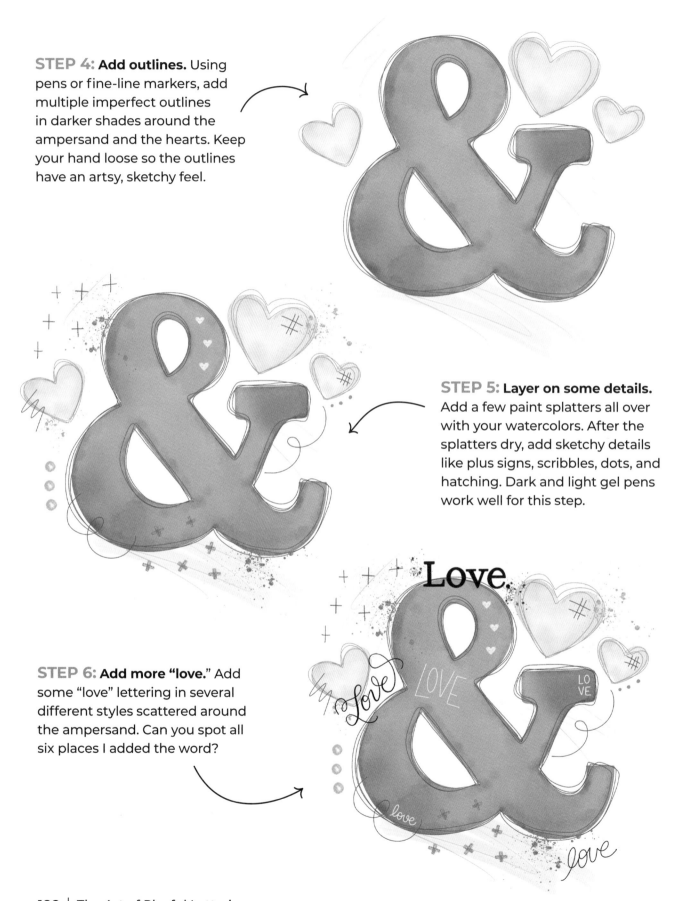

STEP 4: Add outlines. Using pens or fine-line markers, add multiple imperfect outlines in darker shades around the ampersand and the hearts. Keep your hand loose so the outlines have an artsy, sketchy feel.

STEP 5: Layer on some details. Add a few paint splatters all over with your watercolors. After the splatters dry, add sketchy details like plus signs, scribbles, dots, and hatching. Dark and light gel pens work well for this step.

STEP 6: Add more "love." Add some "love" lettering in several different styles scattered around the ampersand. Can you spot all six places I added the word?

Level Up
Your Lettering

Try following this project technique again, but using more colors
and a much-longer phrase. I just love creating in this style!

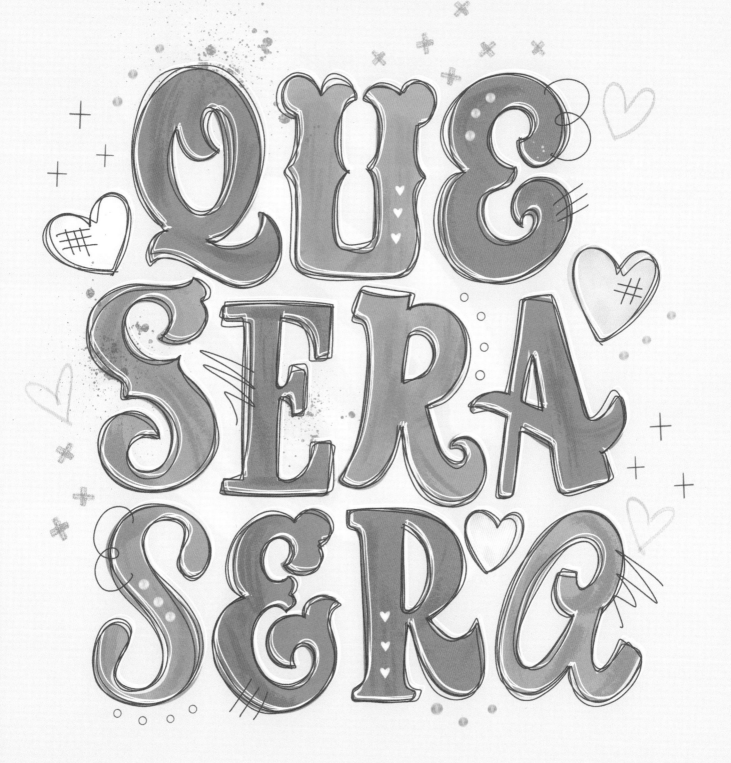

Project Five:

Creative Kitsch

STYLES USED: **monoline sans serif**

Kitschy art is characterized by eccentricity, gratuitousness, and melodrama. Love it or hate it, it's a real style. Even if you think you're familiar, take a minute to search the internet for at least three or four pieces of kitschy art that appeal to you to use for inspiration for your own piece. Depending on what mixed media you use, your final artwork will look different than mine, but you can follow the technique and even use the "stay weird" phrase.

SUPPLIES

- Cardstock
- Assorted mixed-media such as scrapbook papers, magazines, paint, stamps, stickers, etc.
- Scissors
- Pencil
- Eraser
- Markers and gel pens
- Tape and/or glue

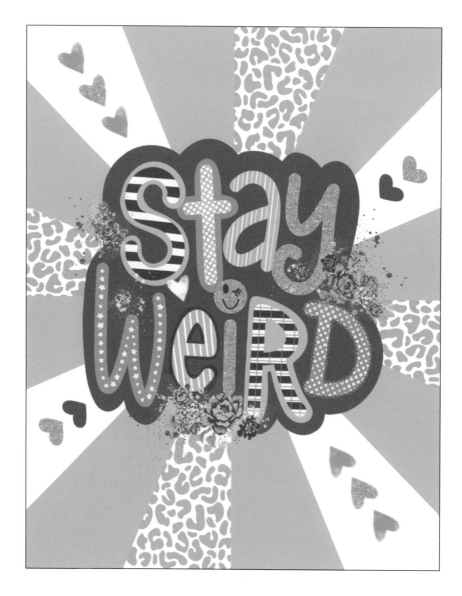

STEP 1: Sketch out the structure. Because this piece uses various mixed media, it's helpful to do a little preplanning. Come up with a basic sketch of your project, including the lettering. I opted to fill the full space of a letter-sized sheet of cardstock. Check out my initial sketch and then get to work on yours.

STEP 2: Add background elements. Cut your main background elements out of scrapbook paper. In my case, I chose stripes of light blue and a background of dark blue for the lettering. Glue these pieces down.

STEP 3: Add the letters. Cut out your letters from a combination of your mixed media. Try mixing solid, patterned, and glitter papers. Glue everything down once you're happy with how the elements work together. I wanted my letter "i" to have a kitschy, winking, smiley face, so I added that in this step.

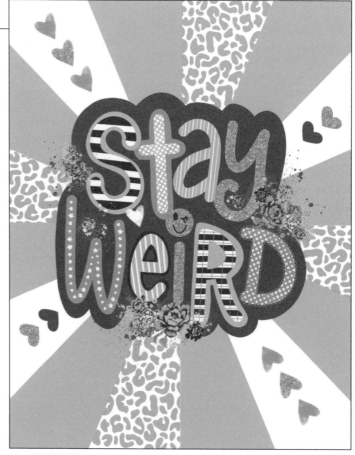

STEP 4: Finish with decoration. Add elements such as florals, animal prints, hearts, and splatters. You can use a combination of gel pens, paint, stamps, magazine cutouts, or, really, whatever you want. Take as much time as you need and have fun with this step. It's where we creatively blur the lines between cute and kitschy!

Level Up
Your Lettering

Try incorporating a personal photo into your kitschy lettering art.
I did a piece featuring our Great Dane, Marley. Sometimes, leveling up your
lettering means knowing when less is more—for this piece, with the focus
on Marley's cute face, I deemphasized the lettering a little bit.

Sketch Note

STYLES USED: **mixed lettering inspired by Switcheroo**

This is such a fun project to get in touch with yourself and can double as an About Me page or post for your website or social media! If you're unfamiliar with the "sketch note" style of artistic notetaking, pop online and search to help inspire your project. You'll also need to make a list of 10 things you love before you get started—you'll incorporate all of these into your piece!

SUPPLIES

- Paper of choice (mixed-media paper is recommended)
- Pencil
- Eraser
- Assorted coloring supplies (such as fine-liner pens, colored pencils, markers, gel pens, etc.)

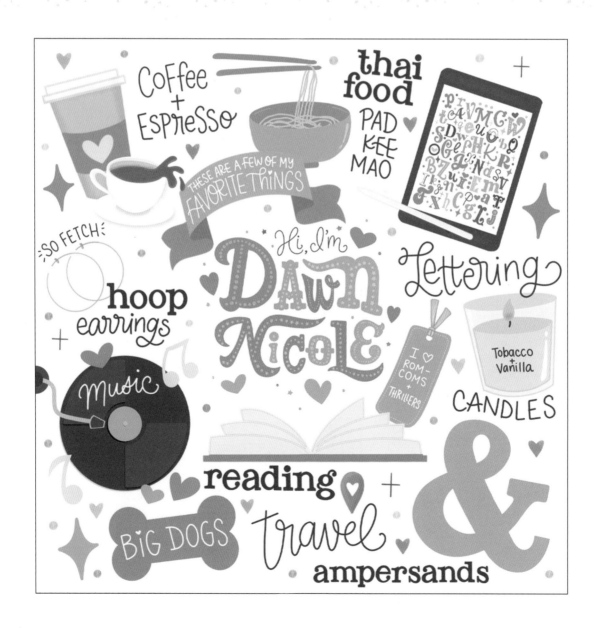

STEP 1: Create the structure. Using any lettering style you'd like, sketch your name in the center of the page. Imagine dividing a square into a grid with nine equal squares, like tic-tac-toe. Keep your lettering within the middle square of the grid so you'll have ample room for the following steps.

STEP 2: Add illustrations. Roughly place and sketch out drawings that illustrate your ten favorite things. Don't completely fill the space—leave room for additional lettering that will be added in the next step.

STEP 3: Add more lettering. Sketch in smaller lettering for your favorite things, filling in most of the space around your illustrations. I used a combination of the Logophile style and simple monoline styles in my own handwriting.

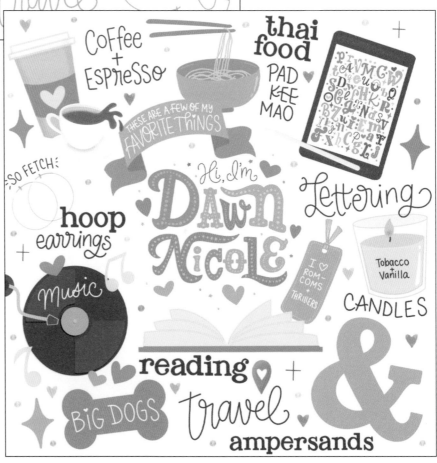

STEP 4: Add color and detail. Coloring may take quite a while, depending on how detailed you get. Fill empty space using stars, hearts, and dots. And that's it! Isn't the result fun?

Level Up
Your Lettering

Want to try this style with a longer poem, song lyric, or quote that doesn't have obvious illustrations? Use a doodle-y lettering style, simple shapes, and a lot of colors to achieve a similar look! I've used one of my favorite Shakespeare quotes here.

"We are such stuff as Dreams are made on, and our little Life is rounded with a sleep." -SHAKESPEARE

EXTRAS

CHAPTER 6:
Extra Goodies

We're not quite done here! In this chapter you'll find some practice pages to photocopy and reuse endlessly as you work on mastering any lettering style. There is also a 30-day lettering challenge that I know you're going to love. Just because the book is over doesn't mean your lettering journey stops here—far from it!
I can't wait to see what you create.

#30-DAY Lettering CHALLENGE

The hardest part of practicing hand lettering can be deciding what to draw, so I've compiled a list of prompts for you. Take what you've learned in this book and practice, practice, practice. Beyond that, there are no rules (except to have fun, of course). If a 30-day challenge feels too overwhelming, try doing one prompt weekly instead. No rules, remember?

Post your lettering to Instagram and use the hashtag #PlayfulLetteringBook so I can see it. I'll do my best to share your work on my Instagram stories! You can find me on the 'gram at @bydawnnicole.

 Happy lettering, my creative friends!

Practice makes progress.

1. Look Both Ways

2. Main Character Energy

3. Kindness Is Magic

4. Lift Each Other Up

5. Take the High Road

6. Live Out Loud

7. Chef's Kiss

8. Meet Cute

9. Good Energy Only

10. C'est La Vie

11. Don't Forget to Have Fun

12. Keep Your Head Up

13. Plot Twist

14. One Day at a Time

15. Choose the Scenic Route

16. Easy Does It

17. Live an Unrushed Life

18. Take Deep Breaths

19. Out of Office

20. Every Letter Tells a Story

21. Feel the Sunshine

22. Adventure is worthwhile. —AESOP

23. In Full Bloom

24. Show Grace

25. Once Upon a Time . . .

26. Take Heart

27. Make a Wish

28. Seek Beauty

29. Against All Odds

30. A light heart lives long. —SHAKESPEARE

Photocopy these lined sheets for endless practicing opportunities.

About the Author

Dawn Nicole Warnaar is an artist specializing in playful lettering and illustration. She holds a bachelor of arts in English, an MBA, and an advanced certificate in graphic design and branding. Notable client work includes designing a coloring book–style Valentine's Day box for Krispy Kreme Doughnuts, doing live in-store calligraphy for Kendra Scott Charleston, and creating a hand-lettered book cover for *Be Kind to Yourself* (Megan Logan, Better Day Books). She has taught workshops at Pinners Conference Atlanta and Salt Lake City for Tombow and a Wedding Calligraphy workshop in Charleston, South Carolina, for Mixbook Photo Co. Dawn is an Enneagram Type 1w9 with a love of kindness, coffee, reading, ampersands, Mondays, hoop earrings, Thai food, and her Apple Pencil. She resides near St. Louis, Missouri, with her Air Force husband, their three school-aged children, and three dogs. To learn more, visit www.bydawnnicole.com and @bydawnnicole on Instagram.

DAWN'S MISSION STATEMENT

Educate. Uplift. Inspire.

As a lettering artist, I aim to educate and inspire makers to get creative daily while embracing a spirit of community over competition. I believe that growing your lettering skills is a lifelong journey and that focusing on competing with yourself brings more joy than comparing your work to others.

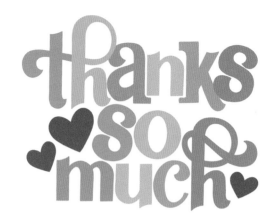

Acknowledgments

The fact that I can spend a lot of my days drawing and calling it work is not lost on me. I wouldn't be able to call being a creativepreneur my career if it weren't for the support of so many lovely humans.

To my husband, Justin. Thank you for always encouraging me and lifting me up. Your support has never wavered over the years, and I'm so lucky to do this life with you.

To my kiddos: Gavin, Chloe, and Quinn. You are the joy of my life and the best thing I ever have or will create. So much of my inspiration comes from the three of you.

Thank you, Mom, for always being my biggest supporter and number one fangirl. Thank you for catching my typos and proudly sharing everything I make with the love only a Momma can give.

So much of my creative (and perfectionistic) tendencies come from you, Dad. In the 23 short years I had you here on this Earth, you lived your gifts of creativity out loud daily. Thank you for instilling a love of making things pretty in me. I miss you.

A book like this doesn't happen without a seriously talented team. I'm so happy to have found a place among the Better Day Books roster of creatives. To Peg Couch (publisher extraordinaire), Colleen Dorsey (editor), Michael Douglas (designer), and Llara Pazdan (designer). Thank you, thank you, thank you. Creating this book is a dream come true, and you are a huge part of making it happen.

Finally, thank you to supporters of my art and those who picked up this book. I quite literally couldn't do what I do without you. So, from the bottom of my heart, thank you.

If you ask me what I came to do in this world, I, an artist, will answer you: I am here to live out loud.

—ÉMILE ZOLA

Index

Note: Page numbers in *italics* indicate projects.

BETTER DAY BOOKS®

HAPPY · CREATIVE · CURATED

Business is personal at Better Day Books. We were founded on the belief that all people are creative and that making things by hand is inherently good for us. It's important to us that you know how much we appreciate your support. The book you are holding in your hands was crafted with the artistic passion of the author and brought to life by a team of wildly enthusiastic creatives who believed it could inspire you. If it did, please drop us a line and let us know about it. Connect with us on Instagram, post a photo of your art, and let us know what other creative pursuits you are interested in learning about. It all matters to us. You're kind of a big deal.

it's a good day to have a better day!®

www.betterdaybooks.com
⊙ better_day_books